Salvador
DALÍ
EXPLORING THE IRRATIONAL

Edmund Swinglehurst

TIGER BOOKS INTERNATIONAL
LONDON

This edition published in 1996 by
Tiger Books International PLC, Twickenham

This book was designed and produced by
Todtri Productions Limited
P.O. Box 572, New York, NY 10116-0572
FAX: (212) 279-1241

Printed and bound in Singapore

ISBN 1-85501-833-0

Author: Edmund Swinglehurst

Publisher: Robert M. Tod
Editorial Director: Elizabeth Loonan
Book Designer: Mark Weinberg
Production Coordinator: Heather Weigel
Senior Editor: Edward Douglas
Project Editor: Cynthia Sternau
Assistant Editor: Donald Kennison
Picture Reseacher: Laura Wyss
Desktop Associate: Paul Kachur
Typesetting: Command-O, NYC

Illustrations copyright ©1996
Demart Pro Arte, Geneva/Artists Rights Society (ARS), N.Y.

Picture Credits

Albright Knox Gallery, Buffalo, New York 82

The Art Institute of Chicago, Illinois 63, 78

Boymans-van Beunigen Museum, Rotterdam 65, 71, 76, 77, 84, 97

Christie's, London/Art Resource, New York 40–41

Coleccion Thyssen-Bornemisza, Madrid 18, 92

Fundacion Gala-Salvador Dalí, Figueras 30, 42, 86, 87, 88–89,
98, 103, 112, 113, 114, 115, 122, 123, 124–125, 126, 127

Glasgow Museums: The St. Mungo Museum of Religious Life & Art, Glasgow 102

Ikeda Museum, Japan 124

Kunstmuseum, Basel 69, 74

Kunstammlung Nordrhein-Westfalen, Düsseldorf 72–73

Marquette University, Haggerty Museum of Art, Milwaukee, Wisconsin 101

The Metropolitan Museum of Art, New York 119

Moderna Museet, Stockholm 24–25

Munson Williams Proctor Museum, Utica, New York 47

Musée National d'Art Moderne, Centre Georges Pompidou, Paris 12, 22–23

Museo d'Arte Contemporanea, Madrid 46

Museo Nacional, Centro de Arte Reina Sofia, Madrid 6, 8–9, 10, 13, 15, 58, 80

The Museum of Modern Art, New York 17, 21, 31, 33

The National Gallery of Art, Washington, D.C. 107

National Gallery of Canada, Ottawa 26

The Philadelphia Museum of Art, Pennsylvania 5, 55

Pers Gallery, New York/Art Resource, New York 27

Private collection/Art Resource, New York 11, 43, 56–57, 62, 75, 79, 118

Salvador Dalí Museum, St. Petersburg, Florida 16, 20, 34, 36–37, 38, 39, 44–45,
60–61, 64, 66–67, 68, 83, 90–91, 93, 94, 95, 100, 104–105, 106, 108–109, 110, 116, 117

Santa Barbara Museum of Art, California 96

The Solomon R. Guggenheim Museum, New York 35

Staatliche Museum zu Preussicher Kulturbesitz, Berlin 120–121

The Tate Gallery, London/Art Resource, New York 48, 51, 52–53, 54, 59, 71

Victoria & Albert Museum, London/Art Resource, New York 50

Wadsworth Atheneum, Hartford, Connecticut 81

Yale National Gallery, New Haven, Connecticut 28–29

Contents

Introduction

Salvador Dalí became during his lifetime one of the most famous and talked about figures in twentieth-century art. He combined a facility for draftsmanship and an agile mind with the showmanship of P. T. Barnum and a Marx Brothers-like humor. The subjects of his work were nearly always controversial, dealing forthrightly yet flamboyantly with sex and the subconscious. In addition, the artist was obsessed by his personal version of traditional legends and mythology as well as with discovering via art an explanation of the universe in terms of modern physics and religion. Little wonder, then, that art lovers argue about him still and that the world at large regards him as a prototype of the modern artist and worldly bohemian.

Dalí was very much an artist of his time, ever aware of all the new trends in art and design in addition to the science of the human psyche and its environment. Unlike other artists, he did not pursue new methods of expression or seek a new language of painting; he believed that the Old Masters, especially those of the Renaissance era, had brought the techniques of painting to such perfection that it was difficult to improve on them. He made endless investigations into these techniques, adapting them to his own use. As a result he portrayed in his work—in a clear and elegant manner and with fine craftsmanship, mindful of the painters of the Renaissance—the provocative, singular ideas that offered what he believed to be an explanation of his own world and that of his contemporaries.

Similar to most classical masters, as an artist Dalí spoke in metaphors and invented his own versions of old mythologies. Perhaps this is difficult to comprehend by those who expect a rational explanation of all things; this is not, however, nor has it ever been, the purpose of great art, which speaks for itself to those who look patiently and with an open mind.

**Soft Construction with Boiled Beans:
Premonition of Civil War**

*detail; 1936. The Louise and Walter Arensberg Collection,
The Philadelphia Museum of Art, Philadelphia, Pennsylvania.*

In one of Dalí's most celebrated anti-war paintings, the soft flesh of the female body in the center of the painting is contrasted with the horny hands, one of which squeezes her breast while the one other presses into the ground like an old vine root. In the rear is a little figure of an ordinary man, a victim of the Civil War.

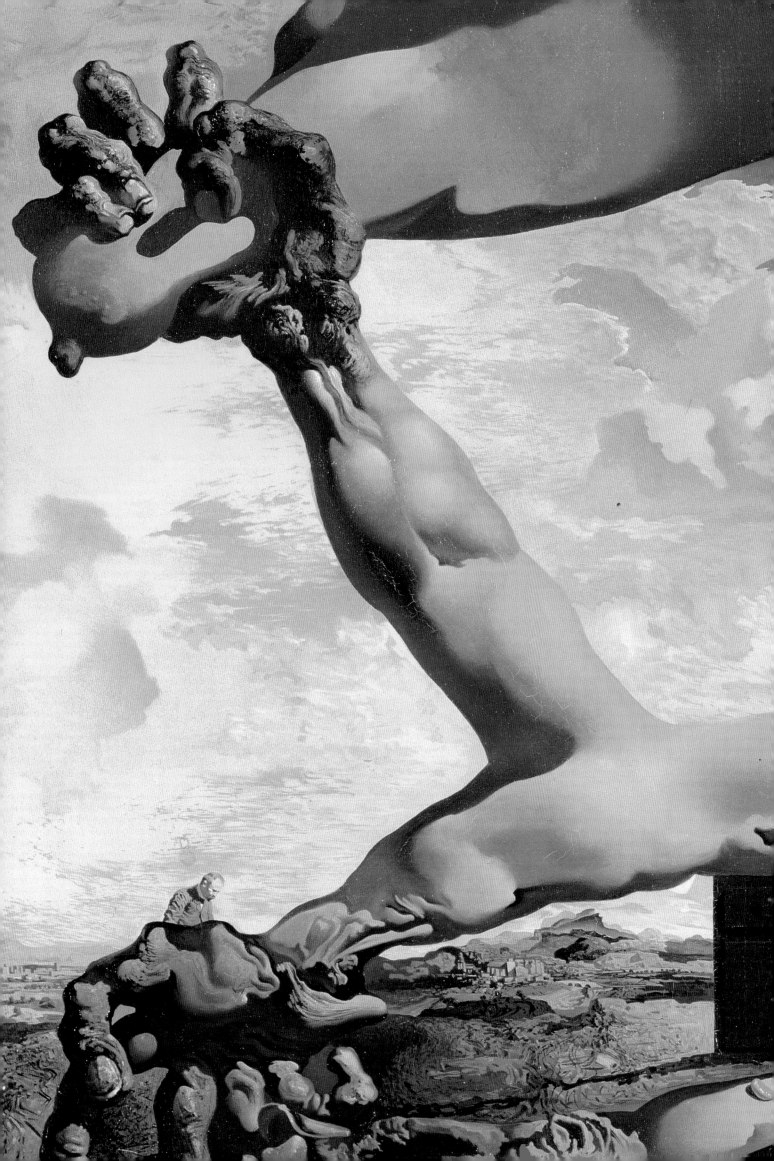

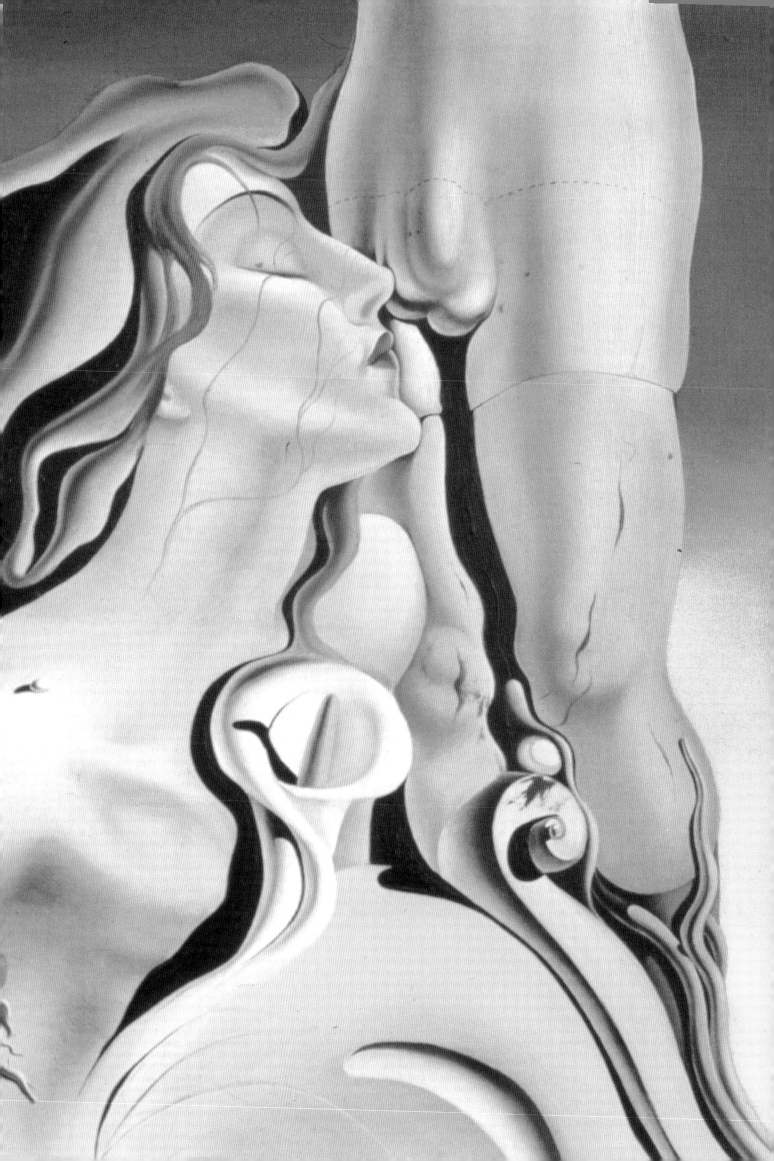

The Road to Surrealism

Salvador Dalí's stature in the history of modern art is similar to that of the perception of his paintings—tangible and clearly visible while at the same time full of ambiguities and double vision. From what is known of his early youth it seems that he was driven by a desire to be different from his contemporaries, yet he was also someone who wanted to be recognized by his peers as a superior individual in his own right.

A psychological explanation—and Dalí himself was fond of these—might be that he had a strong awareness of his own inadequacy, for which he needed to compensate. But if this was so, where did such feelings spring from and how did they develop? His home life in the small Catalonian town of Figueras in northern Spain seems to have been a happy one and typical of that of a middle-class provincial family.

IN THE BEGINNING

Salvador Felipe Jacinto Dalí y Domènech was born on May 11, 1904. His father was the public notary of Figueras, aware of his status in the community and, like many Catalans, an anti-Madrid republican as well as an atheist. His mother, Felipa Domenach, was also typical of her class. She was a dedicated wife and mother and a staunch Catholic who, no doubt, insisted that her family attend church regularly. Both were loving parents to Salvador and his younger sister, Ana Maria, and provided them with the best education then available.

The Great Masturbator

detail; 1929. Museo Centro Nacional Centro
de Arte Reina Sofia, Madrid.
Dalí's sexual phobias are summed up in this detail.
A woman's head is set by the ambiguous genitals of a man with streaks of blood on his legs, suggesting he has been castrated—the young Dalí's greatest fear. A calla lily with its hard, yellow pistil is an obvious sexual symbol.

In time, Salvador came to be convinced that his parents' love for him was really love for his elder brother, who had died in 1903, the year before he was born, and that they believed he was a reincarnation of his brother. This revelation appeared in *The Unspeakable Confessions of Salvador Dalí*, published in 1976, following three previously published volumes of autobiography. Whether this was the exorcising of a trauma or the product of the lively imagination of the lifelong creator of hidden and double-vision images and so-called paranoiac-critical thought processes is a matter for conjecture.

There is no doubt that Dalí was a clever youth—though he liked to claim he was not so—and that he had a natural talent for drawing which he expressed in doodles in his exercise books and in cartoons to amuse his sister. His talent as an artist was encouraged by Ramón Pitchot, a local Impressionist/Pointillist artist and friend of the Dalí family.

Much of the young Dalí's time was spent at his family's seaside home at Cadaqués. Here, the imaginative boy mixed with the local fishermen and working people, absorbing the mythology common to the simple community and learning about the superstitions of its people. This may have influenced his later talent for weaving mythic themes into his art. According to Ana Maria, their home was like everyone else's and a happy one, though the death of their mother from cancer in 1921 was a great emotional blow.

When Dalí was seventeen and already making a name for himself in artistic circles in Figueras, he persuaded his father to help him to get away by funding his art studies in Madrid at the San Fernando Academy of Fine Arts, one of whose most prestigious directors had been the great Francisco Goya. Salvador Dalí set off for Madrid in 1922 with all the confidence of a young man seeking adventure who yet knew he had a safe haven back home. There were, however, shocks to come.

EARLY INFLUENCES AND INTRIGUES

Four years after his mother's death, Dalí's father re-married; his second wife had formerly been his sister-in-law. Dalí considered this to be a betrayal, and it gave rise to one of his earliest mythologies, based on the story of William Tell, whom Dalí turned into an Oedipal father intent on destroying his son. Dalí employed this theme in several paintings over the years, sometimes including his wife, Gala, and Vladimir Ilyich Lenin, whom Dalí regarded as a forbidding father figure (as taught by the Surrealists).

In Madrid Dalí met two men who were to have a vital influence on his life. One was Luis Buñuel, who was to become one of Europe's most well respected avant-garde filmmakers over the next half century. Dalí's other great friend and influence was Federico García Lorca, a poet soon to become one of Spain's finest dramatists and who was later shot by dictator General Francisco Franco's soldiers during the Spanish Civil War. The relationship between Dalí and Lorca was a close one; Lorca's poem "Ode to Salvador Dalí" was published in 1926 and Dalí was to design in 1927 the sets and costumes for a production of Lorca's *Mariana Pineda*.

Both Buñuel and Lorca were part of a new intellectual life in Spain, challenging the conservative and dogmatic doctrines of the political establishment and the Catholic Church, which together largely defined Spanish society at the time. The new ideas stimulated young Dalí's already radical thinking, leading him to quarrel with the methods of the Academy of Fine Arts in Madrid, where he began studying and from which he was expelled in 1926 for fomenting student unrest. By this time he had already had his first one-man show, a well-received exhibition at the Delmau Gallery in Barcelona in November of 1925.

Much of his work at this time had been done as a means of exploring the new trends which were prevalent in the art world of Paris. He tried his hand at Impressionism in *Self-Portrait with Raphaelesque Neck* (1921–22), with a background of the rocks at Cadaqués

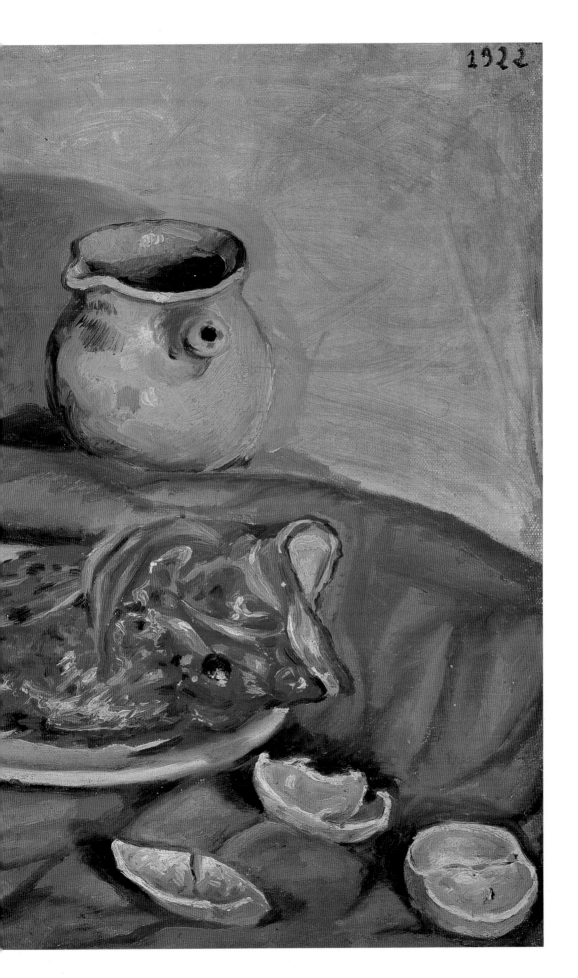

Still Life: Fish

1922, oil on canvas;
11⅞ x 13½ in. (30.5 x 34.6 cm).
Museo Centro Nacional Centro
de Arte Reina Sofia, Madrid.
This charming still life of
a fish reflects Dalí's love
for his home ground, a
sentiment that remained
with him all his life and
inspired him to use the
Cadaqués coast as a back-
ground to many paintings.

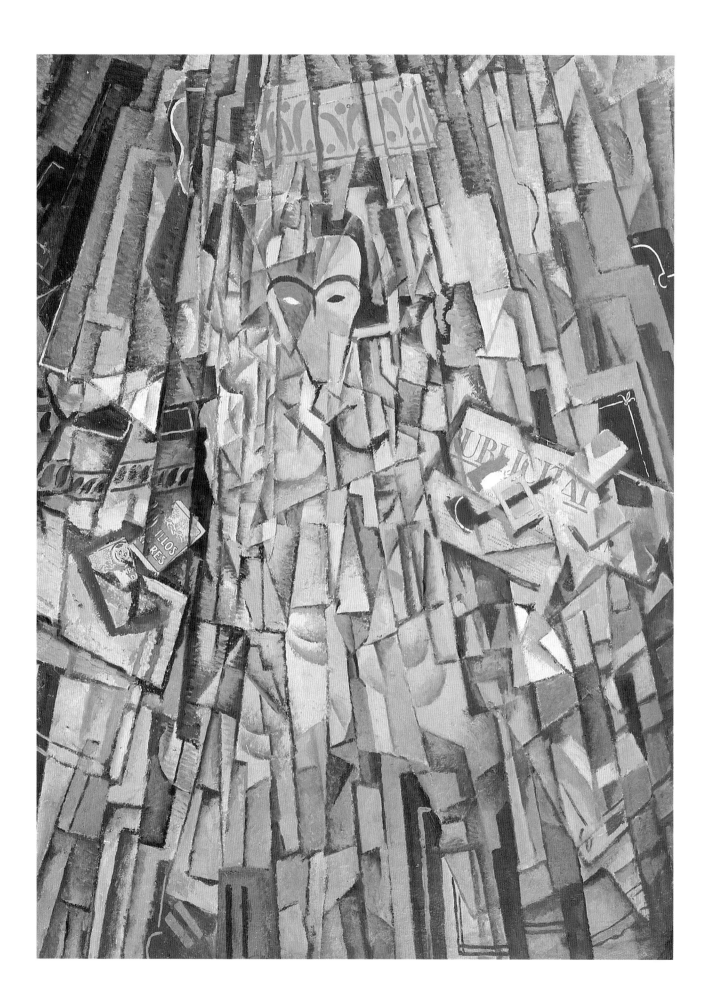

which would remain a typical Dalí landscape motif; then he attempted Cubism, in imitation of its founders Georges Braque and Pablo Picasso, with another self-portrait which he called *Self-Portrait with "La Publicitat"* (a Barcelona newspaper) in 1925. Also in 1925 came another Picasso-esque painting, which Dalí called *Venus and Sailor*. This was one of seventeen paintings included in Dalí's first solo exhibition.

NOTHING NEW

Dalí had not yet seen any originals of contemporary paintings, though there had been an exhibition of contemporary art in Barcelona in 1920. At this time much of the influence on his work was derived from magazine reproductions, many of them provided by Pichot's brother Pepino.

Although Dalí had made a trip to Paris, the center of the art world, with his family in 1926, during which he visited Picasso in his studio, he was in no hurry to make a return visit. Perhaps he wanted to work out for himself what it was that he was looking for, but also, as it turned out later when he had to travel to keep up with his growing world status, because he hated displacing himself from the familiar background of Cadaqués and the Costa Brava in Catalonia.

Another factor influencing Dalí's thought at this time was his lack of any real curiosity about the development of new aesthetic approaches to the techniques of painting. Deep down, as he would soon admit to himself, he felt that the perfection of technique achieved by the Renaissance painters could not be improved upon. It was a feeling confirmed by a trip to Brussels, made during the visit to Paris. Dalí was very impressed by the art of the Flemish masters, with their remarkable attention to detail.

When Dalí returned to Cadaqués after his expulsion from the art school in Madrid, he continued painting in his own way. He produced one painting of his sister lying on some rocks, called *Figure on the Rocks* (1926).

Self-Portrait with *La Publicitat*

1923, gouache and collage on cardboard; 40 x 29 in.

(104.9 x 74.2 cm). Museo Centro Nacional Centro de Arte Reina Sofia, Madrid.
This cubist self-portrait with *La Publicitat*, a Barcelona newspaper, was painted when Dalí was still acquiring information about modern art through magazines supplied by his friend Pichot. The picture concept is derived from the work of Picasso and Braque, though the fragmentation of space is more arbitrary. It is a derivative work, typical of a young talented artist looking for his own means of expression.

Unsatisfied Desires

1928; oil, sea shells, and sand on cardboard; 30 x 24 ³/₈ in. (76.2 x 61.9 cm). Private collection.
Like *Baigneuse* and *Bather*, *Unsatisfied Desires* treats Dalí's familiar theme of masturbation—the intense guilt that, for Dalí, accompanied the act, together with his fear of castration which would be more fully expressed in works such as *The Great Masturbator*.

It looked superficially to be in Picasso's style, however it missed the point of the latter's work, and was merely a realistic study of perspective.

A second exhibition of Dalí's paintings in Barcelona's Delmau Gallery at the end of 1926 was even more enthusiastically received than the first, and may have done something to reconcile Dalí's father to his son's shocking expulsion from the Academy of Fine Arts (which had, of course, closed the door on any chance of an official career for him).

Dalí gladly returned to his admiration for the Renaissance masters and temporarily forgot Paris. But in 1929 there came a summons from his friend Buñuel which he could not ignore. He was invited to Paris to collaborate on a Surrealist film using images dredged up from the subconscious mind. The film

was called *Un Chien andalou*—today considered a Surrealist classic—and it was a short piece intended both to shock bourgeois sensibilities and to ridicule the excesses of the avant-garde. Among the more shocking images is the still notorious scene in which a human eye is sliced in half with a razor, a scene Dalí is known to have inspired. Putrefying donkeys, which figured in other scenes, were also part of Dalí's contribution to the film.

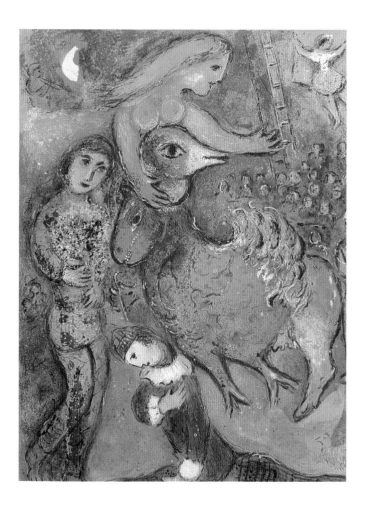

Paranoiac Woman-Horse

1930, oil on canvas; 19¹/₂ x 13¹/₂ in. (50.2 x 65.2 cm).

Musée National d'Art Moderne, Centre Georges Pompidou, Paris.

This painting shows Dalí's tendency towards ambiguity, in which objects become other objects or are hidden in a double image. Here, the woman/horse, both painted in a sexual way, appear also as part of a fishing boat which lies before a column in sand stretching away to a rocky island reminiscent of Dalí's homeland near Cadaqués.

After the film's first public showing at the Théâtre des Ursulines in Paris in October of 1929, Buñuel and Dalí immediately became both celebrated and notorious. *Un Chien andalou* was followed two years later by *L'Age d'Or*, a great critical success for Buñuel but, later, a subject for dispute between him and Dalí, each claiming to have done more on the film than the other. Despite their arguments, their collaboration remained as a landmark in both their artistic lives and set Dalí's steps firmly on the road to Surrealism.

REALIST AND SURREALIST

Even before Dalí went to Paris his work had displayed Surrealist qualities. *Figure at a Window*, a painting from 1925 depicting his sister Ana Maria looking out of a window at the bay in Cadaqués, has the unreal air of a dream, though it is painted with meticulous realism. There is a aura of emptiness but also of invisible presences which may be lurking just out of the picture space—and there is the feeling of silence. If this had been an Impressionist painting, the viewer would sense the atmosphere—hear the sea or the whisper of the breeze; but here life seems to be in suspense. The figure of Ana Maria is isolated, in another world, and her broad behind, a part of the female body which was to obsess Dalí, does not have the sensuality of a Renoir or Degas.

Most Surrealists, such as André Masson, Max Ernst, and Joan Miró, had begun their exploration of the subconscious by freeing their minds of conscious control and allowing thoughts to bubble to the surface without imposing conscious order. This was called "automatism," and in painting it gave rise to abstract shapes that represented images from the subconscious.

Dalí's approach was different. He portrayed images with which the mind was familiar—people, animals, buildings, landscapes—but allowed them to come together without conscious direction. He often fused them in a grotesque manner—limbs turned into fishes or women's torsos into horses, for instance. In a way, this was something like Surrealist automatic writing, in which the words were those familiar from everyday use but strung together in a free way to express free-ranging ideas. Dalí would come to call his unique approach the "paranoiac-critical method." His release of subconscious imagery was that of a madman, he claimed, the difference being of course that he was *not* mad.

Dalí was in fact not yet a member of the Surrealist group headed by André Breton and Max Ernst but his friendship with another Catalan painter and Surrealist, Joan Miró, brought about his membership in the new

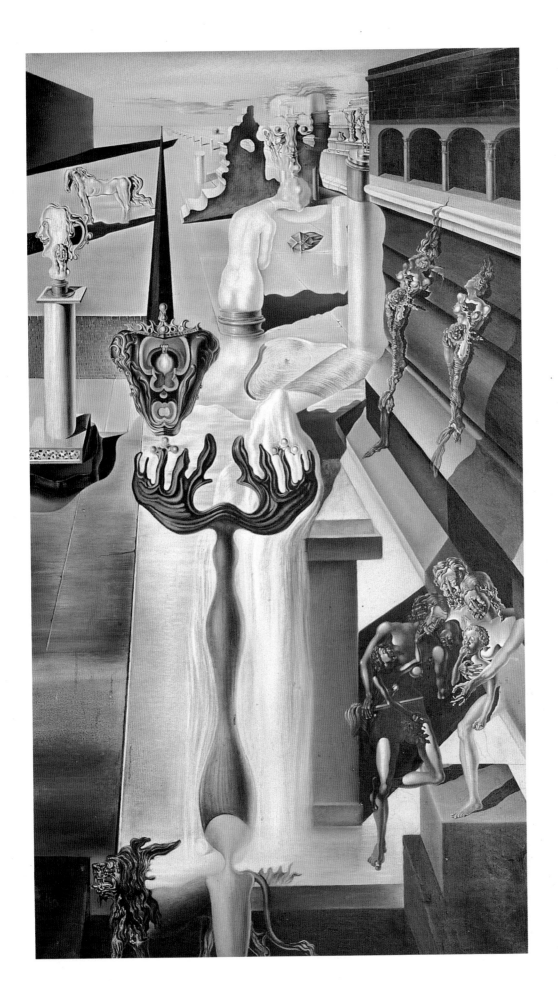

The Invisible Man

1929, oil on canvas; 54½ x 31¼ in.
(140 x 80 cm).Museo Centro
Nacional Centro de Arte Reina
Sofia, Madrid.
The double vision idea,
which obsessed Dalí and
which he used to express
feelings about the
ambiguity of life, is used
effectively in this painting.
Dalí includes pieces of
classical architecture, an
acknowledgment of his
admiration for traditional
European culture, and a
reference to his fear of
castration (bottom right).

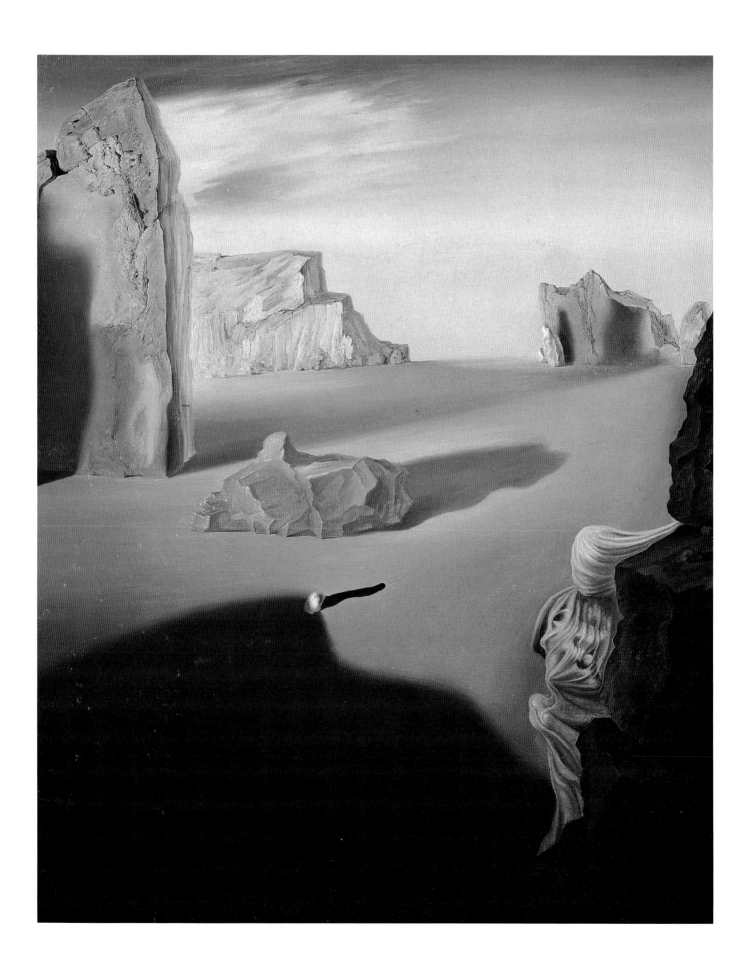

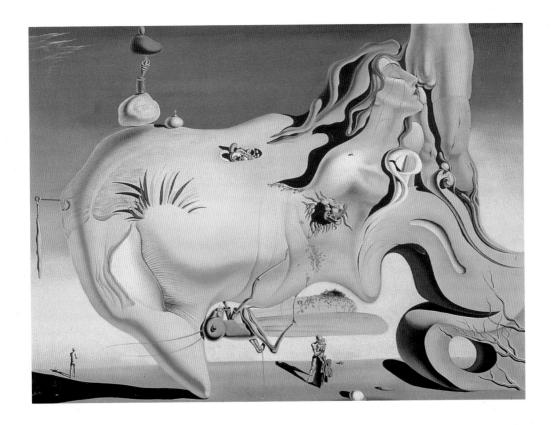

The Great Masturbator

1929, oil on canvas; 43 x 58¾ in. (110 x 150.5 cm). Museo Centro Nacional Centro de Arte Reina Sofia, Madrid.

This was one of Dalí's earliest works, reflecting his preoccupation with his sexual identity and his feelings of guilt and fear of punishment. The soft head on its side is undoubtedly that of the painter himself, his mouth covered by a grasshopper whose abdomen is being eaten by ants, which, for Dalí, were symbolic of corruption.

movement which was beginning to make its broad mark in the artistic and literary circles of Europe.

Breton, who had trained as a doctor and made a deep study of the writings of Sigmund Freud, was the voice of the Surrealists. From Freud, Breton had evolved the idea that by digging up the unvoiced, unexpressed thoughts of the mind Surrealism could break the chains of European thought and create a new way of looking at and living life. A step had been made in this direction earlier by the artist's movement known as Dada, a form of art whose aim was to destroy or make a nonsense of all existing conventional ideas. Among the leaders of Dadaism were Francis Picabia and Tristan Tzara. Surrealism was to give the Dada idea substance and, according to Breton, aid in the destruction of the political order. This led Breton inevitably

Shades of Night Descending

1931, oil on canvas; 23¾ x 25½ in. (61 x 50 cm). Salvador Dalí Museum, St. Petersburg, Florida.

This rather somber painting was made at a time of revolution in Spain, when Alfonso XIII left the country and the Spanish Republic was proclaimed. Dalí, who was a revolutionary as a painter, was, in contrast, conservative in his political views and saw the disturbances in his country as omens of trouble ahead.

to link Surrealism to Communism, at the time the high-minded ideology which was to bring about a new world order.

As far as Dalí was concerned, all this was only of passing interest. Nevertheless, with Miró's support, Dalí joined the Surrealists in 1929, soon after arriving in Paris. Breton regarded this rather dandified Spaniard who liked making picture puzzles with some suspicion, unable to see how he might benefit the cause.

1929 was to be a fateful year for Dalí. After working on *Un Chien andalou* with Buñuel, he returned to Cadaqués to work on an exhibition of his paintings, which the Paris art dealer Camille Goëmans had agreed to display in the autumn. Among Dalí's many visitors that summer was the poet Paul Eluard, who brought with him his wife Gala—soon to become Dalí's mistress, and, later, his wife—and their daughter Cécile.

Dalí was working hard, and the subjects of many of his paintings were based on his own complex problems of sexuality and his relationship with his parents. In *The Great Masturbator*, a head like a soft version of the rocks along the coast of Cadaqués rests on its side, its neck transforming into a woman's head with lips that hover near the ambiguous genitals of a male torso whose bloodied knees suggest some kind of bloodletting, perhaps castration.

This painting is a landmark in Dalí's work, for it expresses well his continuing obsessions with sex, violence, and guilt. It also features the rock formations which were to appear throughout Dalí's paintings and such typical Dalí images as the grasshopper—one of his nightmare insects—with ants crawling over its abdomen suggesting corruption, while below the woman's head is a calla lily with its yellow phallic pistil emerging from the soft, pale petal shape. An important and very personal painting, its inspiration derived from Dalí's own subconscious and, like other paintings of this period, revealed a great deal about the painter's methods and thought.

In another painting of the period, *The First Days of Spring*, the artist seems to be celebrating his own feelings of liberation. The central diagonals could be a road or a stairway leading away to the horizon, while the solitary seated figure on the left suggests someone turning his back on the rest of the painting, which includes a small photo of Dalí as a child and a woman with a grasshopper attached to her breast. In the foreground is a couple, the male plunging his burning hands into a bucket from which a phallic shape is emerging.

A similar vignette appears in *Illumined Pleasures*, wherein the female of the couple has bloodstained

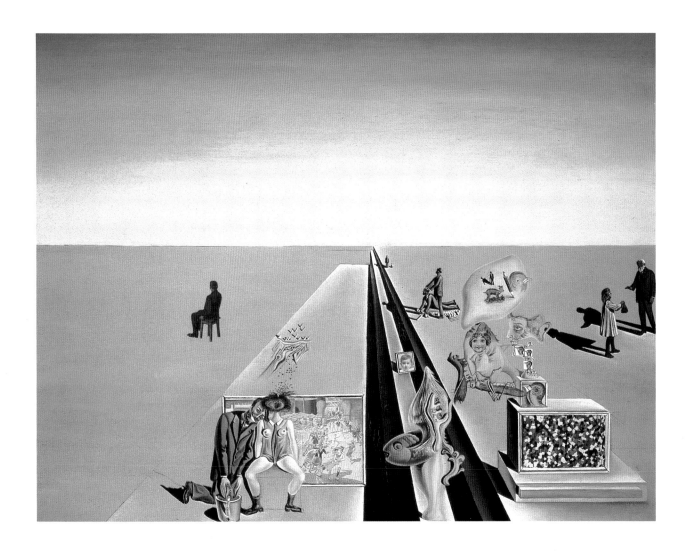

The First Days of Spring
1929, oil and collage on panel; 19½ x 25¼ in. (50 x 65 cm). Salvador Dalí Museum, St. Petersburg, Florida.
After he became interested in the work of Sigmund Freud, Dalí's early paintings explored his own subconscious mind, which was a mystery even to himself. In this painting he seems to have exposed a medley of his fears and obsessions without the plastic unity which he gave to later paintings.

hands; to the left are two hands, one holding a blood-stained knife while the other grips its wrist. The suggestion of castration as a punishment for masturbation is confirmed by a figure (who is evidently turning away in shame) behind a framed picture of cyclists, their leg actions suggesting sexual activity. These paintings and others, including *The Sacred Heart*, were exhibited at the Goëmans Gallery in Paris at the end of 1929.

The shock effect of *Un Chien andalou* as well as the paintings was a public one for Dalí, and one which he relished. At the same time, there was also an unwelcome private aftereffect concerning the painting *The Sacred Heart*. This work depicted an outline of a Madonna with a Sacred Heart in its center and the words "Sometimes I have pleasure in spitting on the portrait of my mother" written roughly around it. What may have been intended as just a publicity stunt of some sort by Dalí became to his father an insult to the sacred memory of his first wife and mother of his family. His distress at the painting, coupled with his disapproval of his son's relationship with Gala Eluard, led him to forbid Dalí to visit the family home ever again. Full of remorse, according to his later recounting of the incident, Dalí cut off all his hair and buried it on the beach of his beloved Cadaqués.

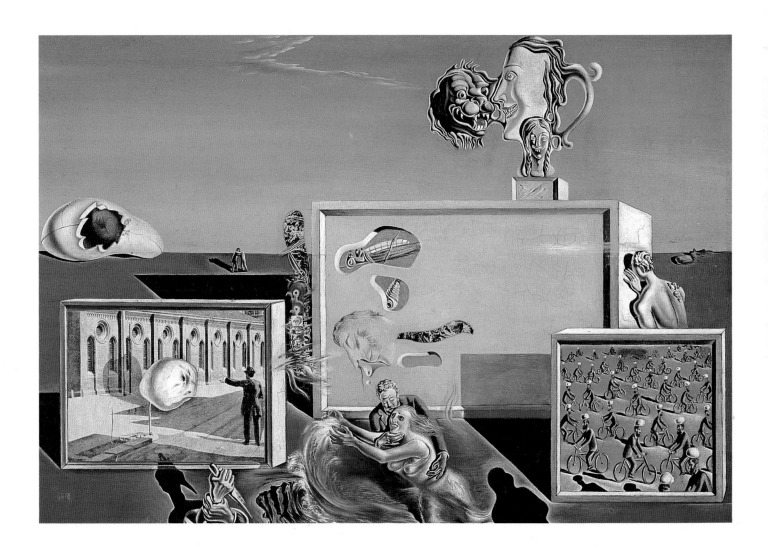

Illumined Pleasures

1929, oil and collage on hardboard; 9½ x 13½ in. (24 x 35 cm). Collection of Sidney and Harriet Janis, The Museum of Modern Art, New York.
Like a shop window of Dalí obsessions, this painting shows, in different frames, a group of cyclists representing
by their leg movements the pumping action of a masturbator, a man turning away in shame, a sky with
a grasshopper, an amorphous shape before a church, and a man grasping a woman with bloodied hands.

Gala and the Umbilicus

Gala Eluard (Russian-born Helena Deluvina Diakonoff) had been the mistress of Max Ernst, a founding member of Dada and then of Surrealism, even while she was the wife of the French poet Paul Eluard. Her meeting with Salvador Dalí in the summer of 1929 was a fateful moment for both of them. To Dalí, Gala, who was nearly ten years older, was the sophisticated, self-assured woman who had been moving in important Parisian artistic circles while he was as yet a simple youth from a small provincial town in northern Spain.

ENTER GALA

Dalí, at first overwhelmed by Gala's style and beauty, burst into hysterical giggles of embarrassment whenever they spoke. He did not know how to deal with her, though he was secretly aroused by her, especially by the sight of her "divine back." On her part, Gala was disconcerted by the tense young man and his preoccupation with masturbation and castration.

Gradiva Rediscovers the Anthropomorphic Ruins— Retrospective Fantasy

1931, oil on canvas; 25¼ x 21 in. (65 x 54 cm).

Coleccion Thyssen-Bornemisza, Madrid.

"Gradiva" was Dalí's name for Gala. The name came from a novel in which a young man, falling in love with a Pompeian statue, later meets her living image and changes his life. Dalí clearly saw this as the story of himself and Gala. Here, she is seen wrapped in the stone ruin in the foreground of the painting.

When Paul Eluard returned alone to Paris, Dalí and Gala found the solution to their problems in sex. "The first kiss," Dalí wrote later, "when our teeth clashed together and our tongues intermingled, was only the beginning of that hunger which was to drive us to bite and to eat to the very core of our beings." Here were images which were to appear frequently in Dalí's subsequent work: The meat chops on people's bodies, the fried eggs, the cannibalism, all suggesting something of the young man's frenetic sexual liberation. When the two went away together for the first time they locked themselves up in their room in the château at Carry-le-Rouet near Marseilles, cut off from the world in a way that was to continue in their married life, even as Dalí became a much-discussed public figure.

Gala—whose reaction to Dalí's frenzied infatuation was, reportedly, to say, "My little boy, we shall never leave each other"—was more than a satisfying lover. Once she had finally left her husband and moved in with Dalí in 1930, she also proved to be an excellent organizer, business manager, and protectress, and when the two eventually married in 1934, Gala's former husband Paul Eluard was one of the witnesses at the ceremony.

To express his feelings about his wonder woman Dalí painted her as Gradiva, the heroine of a popular novel by William Jensen in which Gradiva is the personification of a Pompeian statue with whom a young man has fallen in love and who changes his life. The painting *Gradiva Rediscovers the Anthropomorphic Ruins* (1931) depicts a rocky scene inspired by the Costa Brava rocks, with Gala as Gradiva enfolded in a foreground rock on which rests an inkwell, perhaps a reference to her former poet husband.

PERSISTENT MEMORY

The idea of desolate shores was much in Dalí's mind at the time and he had been painting the empty beach and rocks of Cadaqués—without, however, a theme. The blank was filled in for him, he later recounted, when he saw some Camembert cheese which had begun to go soft and flow over a plate. The sight of it brought a subconscious image to the artist's mind and he began to fill a landscape with melting watches, thus creating one of the most potent images of our time. Dalí called the painting *The Persistence of Memory*.

Completed in 1931, *The Persistence of Memory* has come to symbolize the modern conception of relative time and stimulates in the viewer other deep-seated feelings that are not easy to identify. Within a year of its exhibition at the Pierre Colle Gallery in Paris, what was to become Dalí's most popular painting had been bought by the Museum of Modern Art in New York.

Having been cut off from the family house at Cadaqués because of his father's ban, Dalí obtained

Anthropomorphic Bread—Catalonian Bread

1932, oil on canvas; 9½ x 12⅞ in. (24 x 33 cm).
Salvador Dalí Museum, St. Petersburg, Florida.
Dalí's strong feelings for his native land were expressed over and over again in his paintings in his use of backgrounds of the Costa Brava coast and also in paintings of bread, which also had a religious connotation. Here, the bread is wrapped, the limp watch draped over it suggests the ephemeral nature of life.

The Persistence of Memory (Soft Watches)

detail; 1930. The Museum of Modern Art, New York.
Dalí pairs a soft, melting watch with a solid fob watch covered in ants to show two ways in which time can flow away, either by its liquid character or because it is eaten away by corruption which, in the Dalían sense meant decay, as expressed through the activities of the voracious ants.

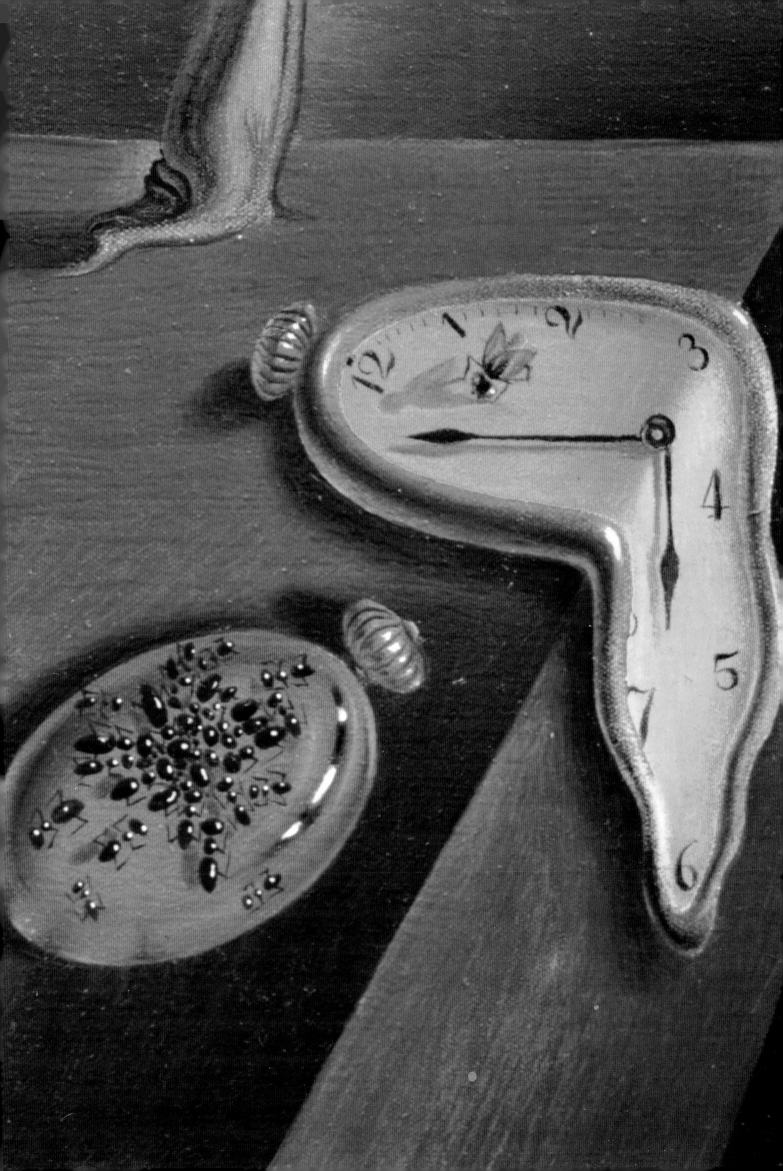

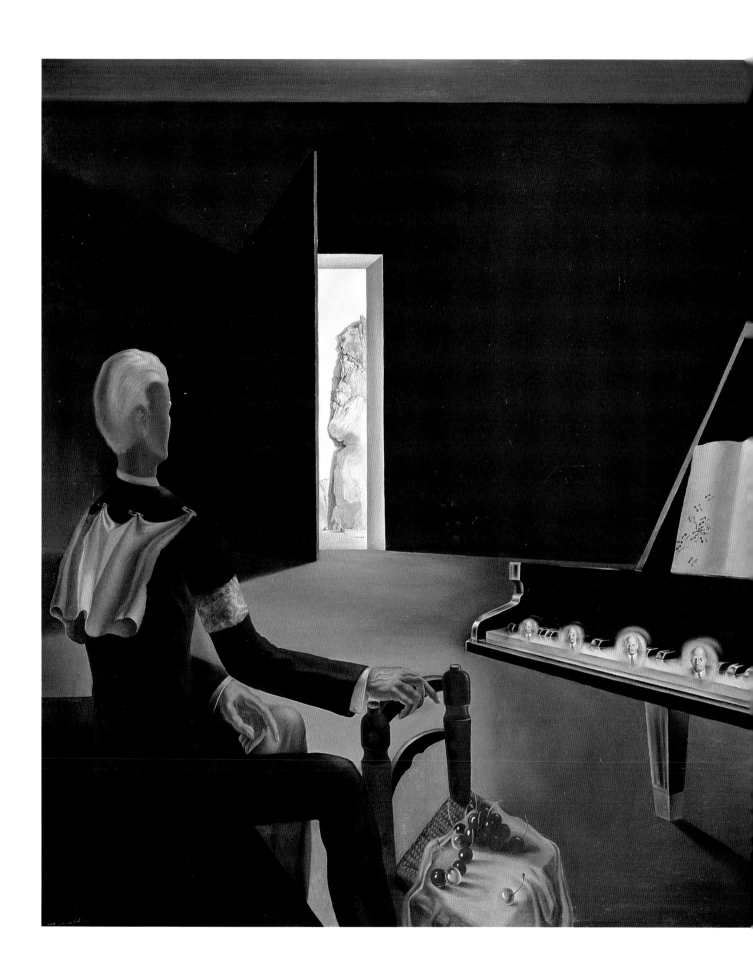

money from a patron, the Vicomte Charles de Noailles, in return for a painting and set up a new home along the coast at nearby Port Lligat. True to his instincts, he was reluctant to leave this treasured coast and homeland.

Dalí was now more convinced than ever that to paint like the great Renaissance painters was his goal, that their techniques would enable him to express the ideas that were most stimulating him. Contact with Buñuel and many discussions with Lorca, who had spent time with him at Cadaqués, had opened up fresh avenues of thought. He began to paint works based on three themes: the legend of William Tell, Millet's *Angelus*, and the Freudian world of the subconscious.

WILLIAM TELL AND LENIN

William Tell symbolized Dalí's complete break from the symbolic umbilical chord which had bound him to home and all it stood for in terms of totems and taboos. The artist's first picture using the theme was titled simply *William Tell* (1933); in the same year he painted *Enigma of William Tell*. Here, the William Tell legend was mixed up with the life of Lenin, the Surrealists' hero. Dalí had already completed in 1931 a painting of Lenin, *Partial Hallucination: Six Apparitions of Lenin on a Piano*, in which the head of the Russian revolutionary appears in a fluorescent halo on a piano keyboard in a darkened room; looking on is a lone father figure, with his hand on the back of a chair with cherries. Here was Dalí's subconscious image of a

Partial Hallucination:
Six Apparitions of Lenin on a Piano
1931, oil on canvas; 44¹/₂ x 57 in. (114 x 146 cm).
Musée National d'Art Moderne, Centre Georges Pompidou, Paris.
Soon after arriving in Paris to work with Luis Buñuel on *Un Chien Andalou*, Dalí was accepted into the Surrealists, a group headed by André Breton. Indifferent to their left-wing political aims, Dalí painted this picture, which offended some of the group from which he later separated. The image of Gala, who became the real idol of his life, appears in the background.

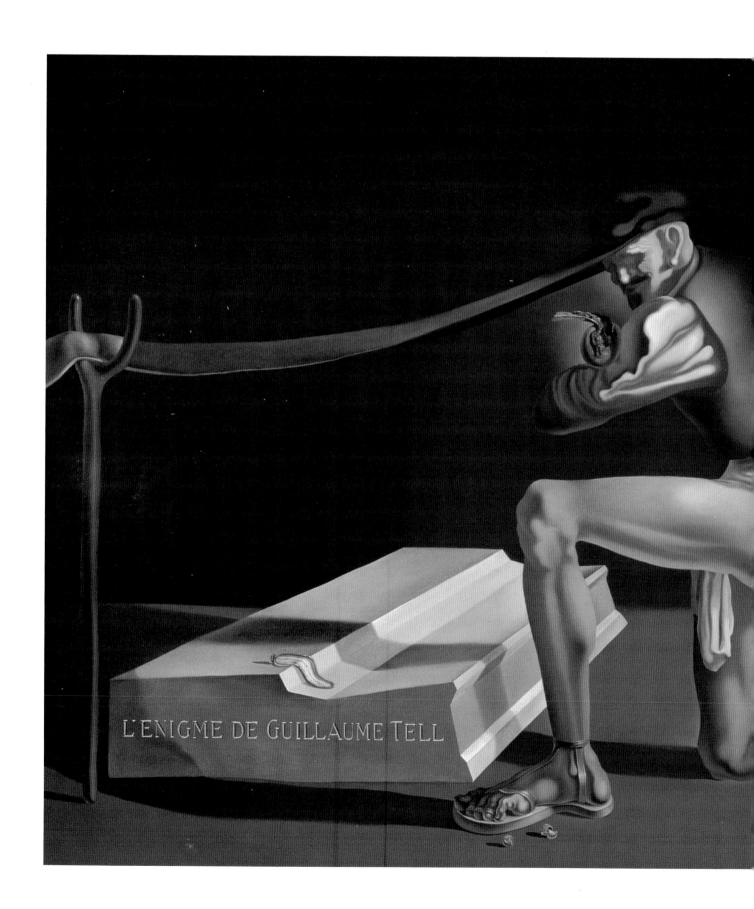

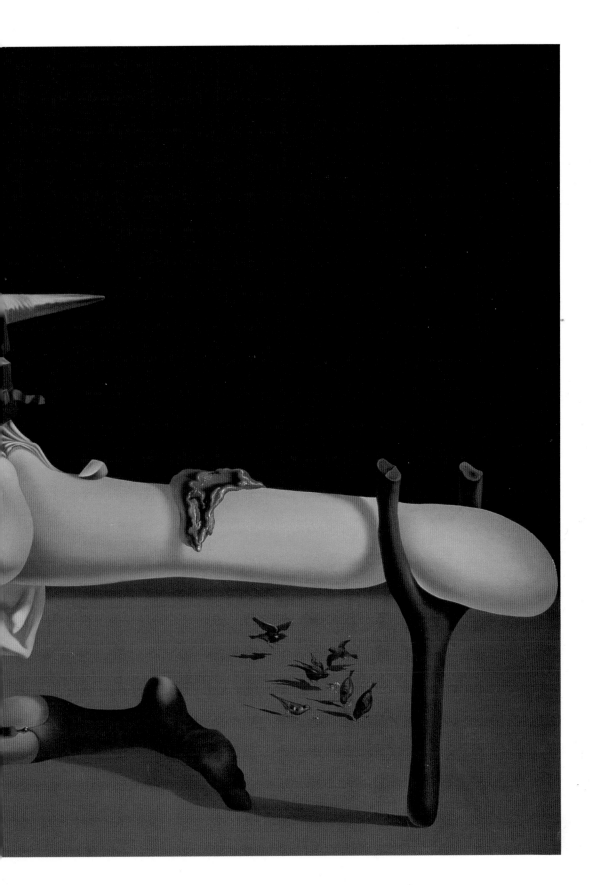

**Enigma
of William Tell**

1933, oil on canvas;

78½ x 135 in.

(201.5 x 346 cm).

Moderna Museet, Stockholm.

The William Tell legend
became for Dalí an
analogy of his feelings
towards his father. In
Dalí's view, William Tell
wanted to kill his son:
thus, the introduction
of Lenin, whom Dalí
also saw as a tyrant fig-
ure after his quarrel with
the Surrealists, into this
painting. The distorted
figure with the elon-
gated buttock so an-
noyed some Parisian
Surrealist/Communists
that they tried to
destroy the painting.

childhood punishment, fear of his father, and the memory of a plate of cherries in the punishment room.

In the *Enigma* painting, Lenin has an enormously elongated buttock supported by a crutch, while another crutch supports the elongated peak of his cap. On the ground, about to be crushed by Lenin's foot, is a child in a perambulator. Lenin is also holding a baby with a cutlet on its head, obviously about to be eaten. The overall meaning of the painting relates that the child is in danger from the father figure, and may represent Dalí's feelings toward his father as well as toward the Surrealists, whose rules were beginning to oppress him.

Some of the Surrealists saw the painting as an insult to Lenin and tried to damage the work. But Breton and other important members of the movement were less concerned. Much more serious from their point of view was Dalí's lack of dedication to their political cause and what they saw as his frivolous approach to art, with its visual puzzles and obsessions with jokes—in, for instance, *The Face of Mae West* (1934), a gouache painting intended as a sketch for a room. (This project was not completed until 1974, when it was done finally for the Teatro Museo Dalí in Figueras.)

DALÍ'S *ANGELUS*

There is no doubt that Dalí's new-found confidence in himself and his work was the result of his relationship with Gala, a woman who satisfied him in every way. But he was not so blind in his love that he did not see other implications in their relationship. This he expressed in his new mythology of *The Angelus*, the best-known painting of the nineteenth-century French painter Jean-François Millet. This celebrated work, loved by the Victorians for its noble sentiment, portrayed two farm workers, a man and woman, bending over as if in prayer at the end of their day's work.

Gala and the *Angelus* of Millet Immediately Preceding the Arrival of the Conic Anamorphoses

1933, oil on panel; 9¼ x 7½ in. (24 x 18.8 cm).
National Gallery of Canada, Ottawa.
The famous painting of the *Angelus* by Millet, the French Barbizon School painter, hung in a classroom in Dalí's school at Figueras. After Dalí met Gala, this painting became an obsessive theme in his own work. Here, Gala sits in a room facing Lenin, with Maxim Gorky appearing round the door with a lobster on his head. The *Angelus* hangs over the door, completing a jamboree of Dalí images and obsessions.

The Architectonic *Angelus* of Millet

1933, oil on canvas; 28½ x 23¾ in. (73 x 61 cm). Perls Gallery, New York.
"The *Angelus* is, to my knowledge, the only painting in the world which permits the immobile presence, the expectant meeting of two beings in a solitary, crepuscular and mortal landscape." —SALVADOR DALÍ

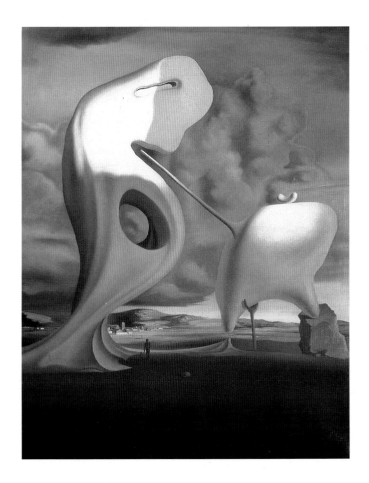

Dalí gave a very different interpretation to Millet's scene as reproduced in his own work. The woman's curved stance became that of a predatory bird and, far from giving thanks for the work which would provide their daily bread, she intended to attack and eat her companion.

Millet's *Angelus* in fact appears in Dalí's picture *Gala and the "Angelus" of Millet Immediately Preceding the Arrival of the Conic Anamorphosis,* painted in 1933. Here, Gala appears sitting in a room in the doorway of which is the seated figure of Lenin; Maxim Gorky (the writer), with a lobster on his head, looks round the door. Above the door is Millet's *Angelus*, so it appears that once again two mythologies have been brought together as one.

"SURREALISME, C'EST MOI"

With his inexhaustible invention and a new energy resulting from his marriage, Dalí began a productive period of painting in which his personal Surrealism took over entirely, leading to a complete break with Breton and the other Surrealists. Dalí was now entirely his own man, and, as he himself claimed, *"Surrealisme, c'est moi"* ("I am Surrealism").

Phantom Wagon

1933, oil on canvas; 10¹/₂ x 12¹/₂ in. (26.7 x 32.4 cm). Yale National Gallery, New Haven, Connecticut.
The double vision *trompe l'oeil* which Dalí adopted in order to express the idea of a reality behind reality first made its appearance in this relatively simple painting of a horse-drawn vehicle crossing the plain of Ampurdan, near Cadaqués. The people sitting in the wagon are also the towers of the town beyond and the wagon's wheels are also stakes in the ground.

To accompany this new exploration Dalí began to employ a double-vision imaging in which objects could be interpreted as one of two things. One of the simplest excursions into this new terrain was *Phantom Wagon* (1933), in which the passengers in a horse-drawn wagon moving away across the plain of Ampurdán, near Cadaqués, also appear to be the towers of the distant village and the wheels look like

stakes on each side of the track. On the left of the picture is a broken amphora, a hint that the ruined Roman town of Ampurias is near Ampurdán. The latter also featured in another enigmatic painting, entitled *The Chemist of Ampurdán in Search of Absolutely Nothing* (1936).

Dalí now had several ways in which to liberate inspiration from the subconscious: There was the Freudian sexual key, the paranoiac-critical method—in which he stirred up thoughts like a madman in a delirium—and the theories of modern physics. Having freed himself from the ties that had bound him to the restricted world of his home, he was now a free-ranging explorer in a world of his own making.

A final defiant look at his childhood fears appeared in *The Specter of Sex Appeal* (1932), in which a kneeling female figure with gray stony sacks forming her belly and breasts is held up by crutches and gazed upon by a young Dalí in a sailor suit against the familiar Costa Brava background. The head of the woman disappears into the cliffs behind her. Gala, too, was an almost constant presence in his work, both in paintings and in sketches for later paintings. In *Dream Places her Hand on a Man's Shoulder* (c. 1932), for example, she appears as the dream, with a head made up of flowers and a back view walking toward a village.

As if in confirmation of his new identity, Dalí now painted a straightforward picture of Gala, *Portrait of Gala* (1935), in which the *Angelus* again appears. This time, however, the foreground is filled with Gala's back, fully dressed, facing a Gala sitting on a wheelbarrow with the *Angelus* picture behind her. The picture, which has the tranquillity and equilibrium of a Dutch interior, is a statement about Dalí and Gala to whom the artist was grateful for having helped him to achieve "the sublime mutation of evil into good, madness into order" and for making his contemporaries accept and share his particular madness.

Despite infidelities, the relationship between Gala and Dalí continued to be very important to the artist, right up until Gala's death in 1982, and was an integral part of his life and livelihood. Her feelings for him were less clear. Never one to offer her own views and opinions, she nevertheless exerted a powerful influence on Dalí even when, as it was rumored, she had a series of other lovers—though it was noted that her husband encouraged this, as he was said to have encouraged orgies of various sexual deviations. As with much of Dalí's private life, while these accounts are necessarily conjecture they would seem—based on his published accounts and his reputation—to have some basis in fact.

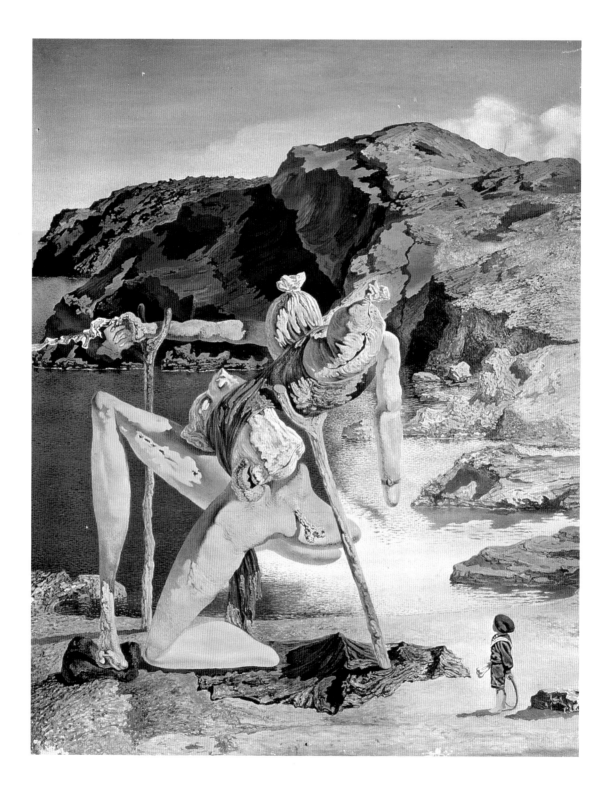

The Specter of Sex Appeal

1934, oil on panel; 7 x 5½ in. (18 x 14 cm). Fundacion Gala-Salvador Dalí, Figueras.

The enormous female figure here, her head melting into the background of the
Cadaqués cliffs, is in a way a forerunner of Dalí's Civil War painting, *Soft Construction
with Boiled Beans*. Here, the figure is more complete than in the later painting, though
it is without feet and hands and has heavy sacks for belly and breasts. The small boy
looking on is Dalí himself, as a child, holding a desiccated penis.

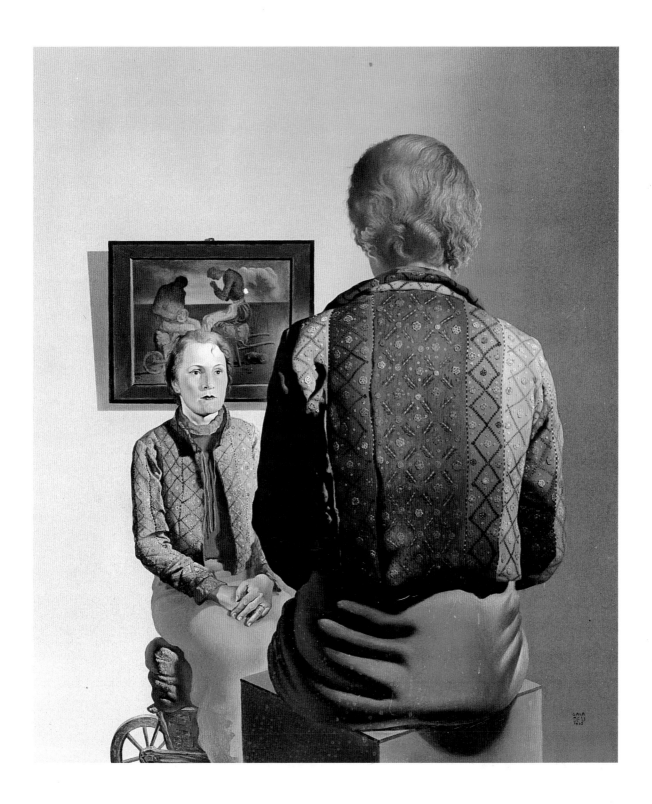

Portrait of Gala

1935, oil on canvas; 12½ x 10½ in. (32.4 x 26.7 cm). The Museum of Modern Art, New York.

Russian-born Gala Eluard was an unconventional woman who changed Dalí's life dramatically, becoming his lover, muse, and business manager. This portrait of her, in which we see both her back view and her front as she faces the artist, with a version of Millet's *Angelus* on the wall behind her, is a fine example of Dalí's smoothly conventional painting technique. He achieved his meticulous detail by painting on primed panels and by using a watchmaker's eyeglass.

The Persistence of Memory (Soft Watches)

1931, oil on canvas; 9½ x 12⅞ in. (24 x 33 cm). The Museum of Modern Art, New York.
One of Dalí's most memorable images was inspired by a soft
Camembert cheese which he observed while Gala was out at a local
cinema. He had already started a painting of a Cadaqués beach scene
and the cheese inspired the subject matter; perhaps the time spent
waiting for Gala to come home gave him the idea for the watches.

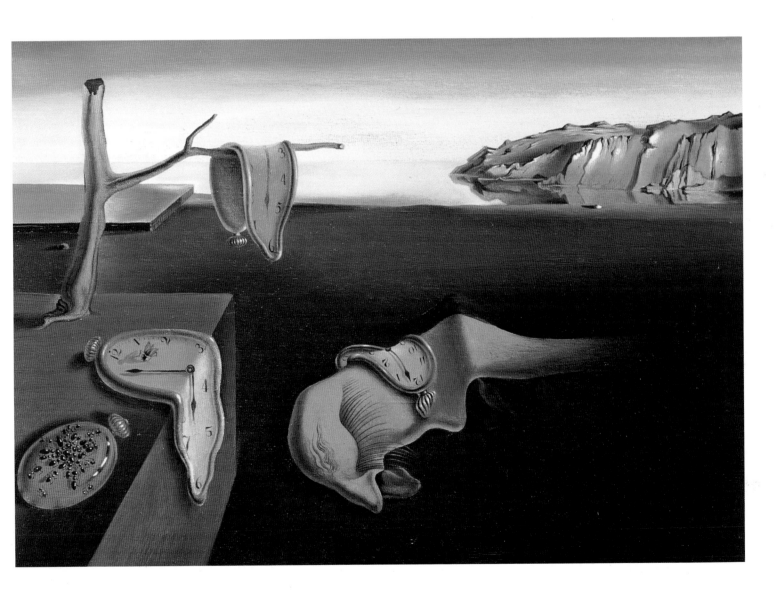

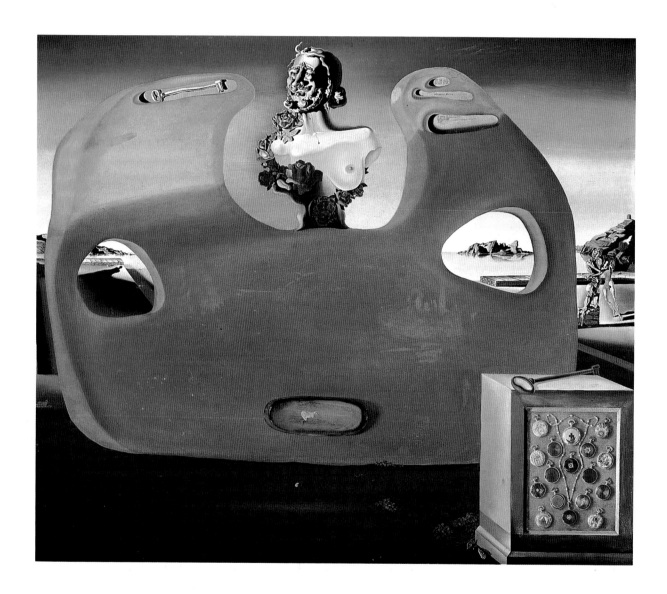

Memory of the Child-Woman

1932, oil on canvas; 38½ x 46½ in. (99 x 119.5 cm).

Salvador Dalí Museum, St. Petersburg, Florida.

The sand-colored shape that dominates this painting looks
feline; between the points of its ears is a hermaphroditic bust.
The setting is a familiar Dalí landscape of the Cadaqués coast.
The glass box with fob watches, in contrast to the melting
watches of other paintings, suggests time standing still.

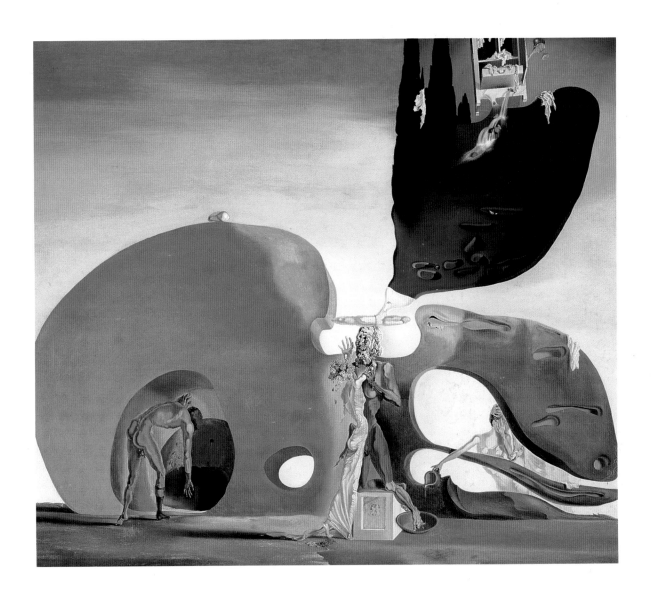

The Birth of Liquid Desires

1932, oil on canvas; 37 x 43½ in. (95 x 112 cm). The Solomon R. Guggenheim Museum, New York.
The decade after he met Gala was the most productive period of Dalí's life.
Freud, the subconscious mind and sex all loomed large in his work as he
struggled to free himself from the umbilical chord which bound him to his
home and past obsessions. The central figures in this painting—a man with a
loaf on his head from which springs a dark shape with cypress trees embracing
a young woman with a head made of flowers—are abstruse sexual imagery.

Diurnal Fantasies

1932, oil on canvas; 31½ x 39 in.
(81 x 100 cm). Salvador Dalí
Museum, St. Petersburg, Florida.
The large, amorphous shape
lying across a green field
with a lowering gray cloud
hanging over it has a decidedly
sexual feel, which is in keeping
with Dalí's interest in every-
thing Freudian at the time he
painted this picture. The key
embedded in the white form is
a Dalí icon and the sheep's skull
is related to Dalí's preoccupation
with corruption and death.

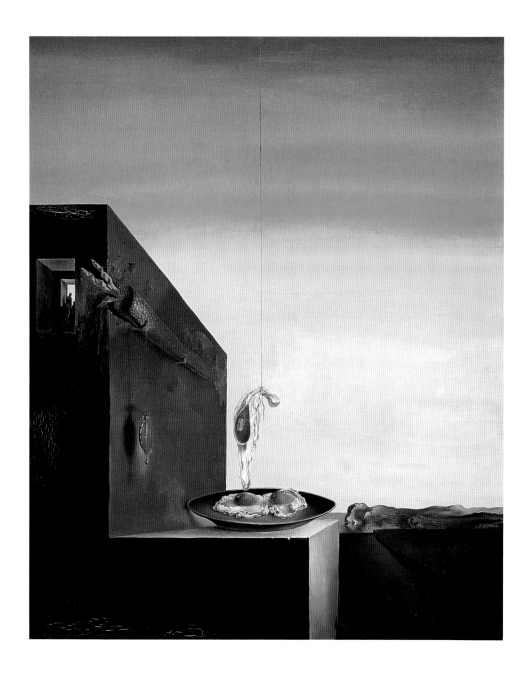

Fried Eggs on the Plate Without the Plate

1932, oil on canvas; 23½ x 16¼ in. (60 x 42 cm). Salvador Dalí Museum, St. Petersburg, Florida.
Dalí's playful fried eggs, with and without a plate, which he painted several times, are
related to the fried eggs in the famous *An Old Woman Frying Eggs* by Velázquez, a painter
whom Dalí admired greatly. Throughout his life, Dalí often referred in his own work to
the work of the great seventeenth-century Spanish painter; at the end of his life he made
a series of paintings based on Velázquez's masterpiece, *Las Meninhas*, in which he placed
fried eggs on a seated dwarf (a dwarf is a prominent figure in the Velázquez painting).

Ghost of Vermeer van Delft, Which Can Be Used as a Table

1934, oil on panel, 7 x 5½ in. (18 x 14 cm). Salvador Dalí Museum, St. Petersburg, Florida.
Dalí greatly admired the work of the Dutch painter Vermeer and acknowledges his importance to him in this painting, where he has placed a bottle of beer on the enormously extended leg of the figure. The composition is simple compared to some of Dalí's other work of the mid-1930s, perhaps as a tribute to Vermeer's own simplicity.

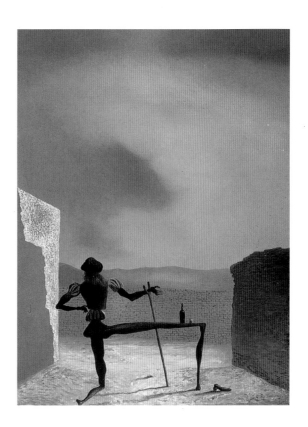

FOLLOWING PAGE:

The Enigma of My Desire or Ma Mere, Ma Mere

1929, oil on canvas; 43⅜ x 59 in. (110.8 x 149.8 cm). Christi's, London.
"But eroticism comes before anything else; the eroticism that flows within us and springs from the helicoidal structure that I painted in the deoxyribonucleic cell." —SALVADOR DALí

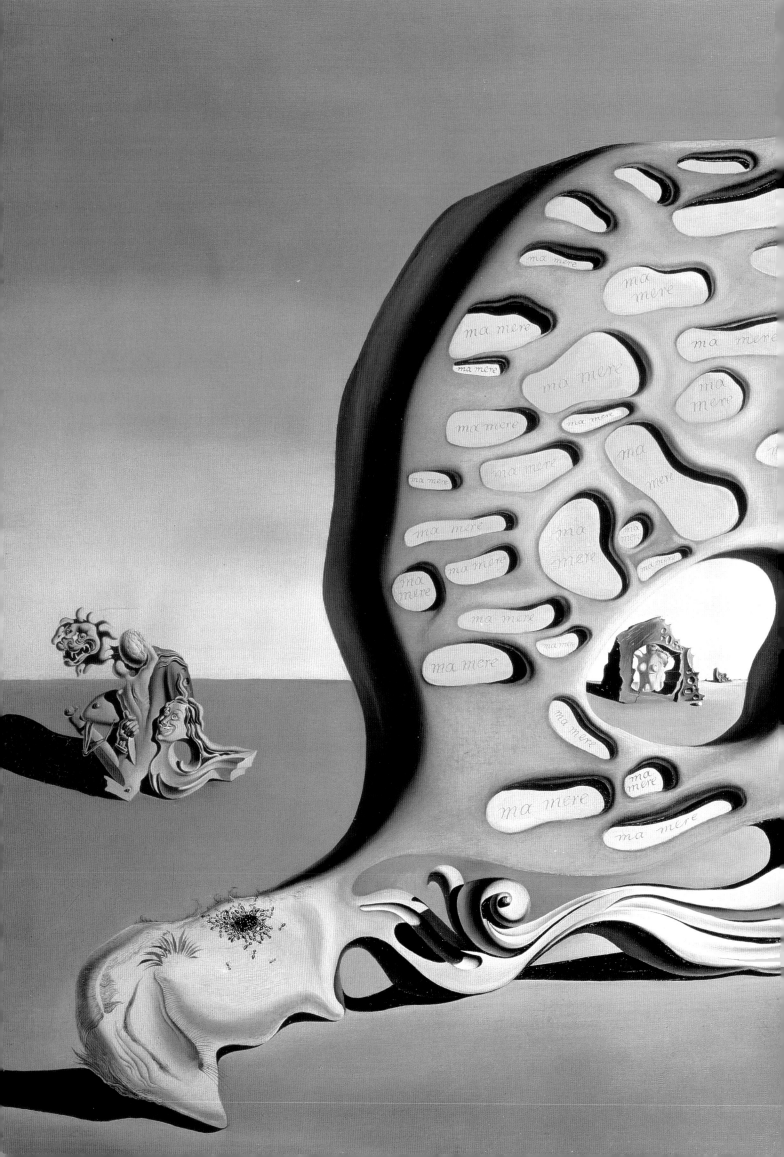

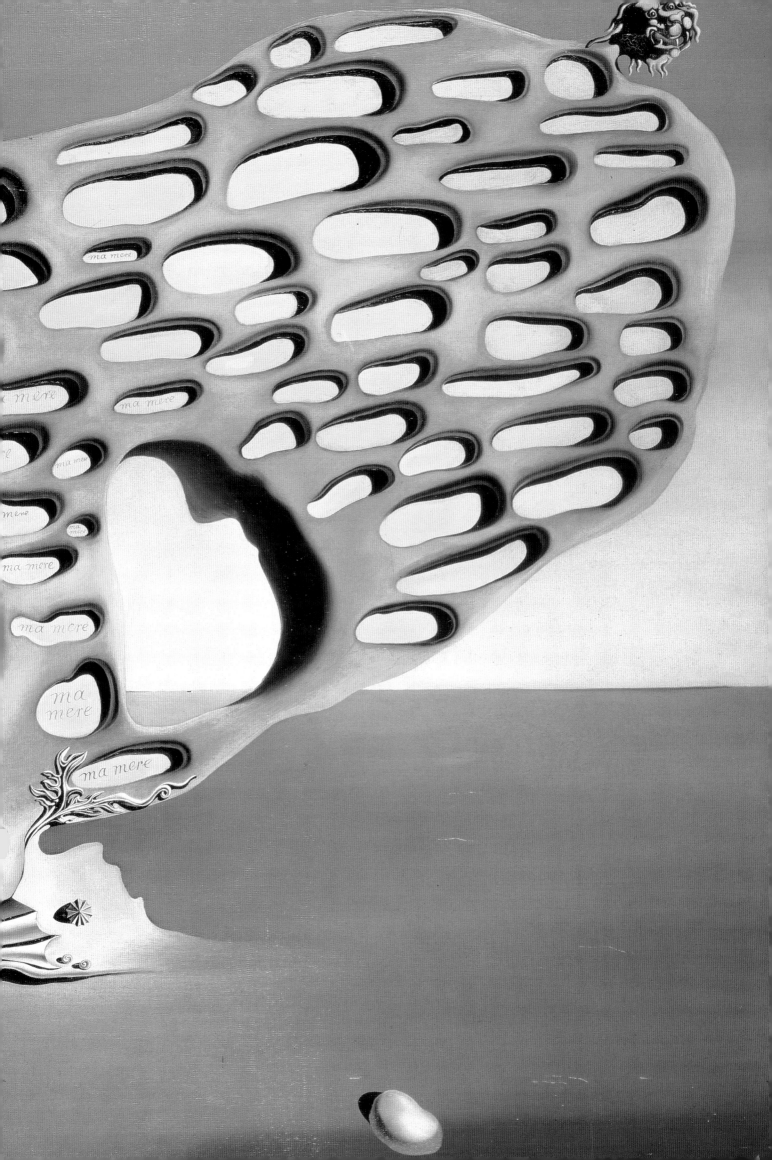

Singularities

1935–36, oil on panel; 15¾ x 20 in. (40.5 x 51.1 cm). Fundacion Gala-Salvador Dalí, Figueras.
This mysterious painting is no longer the record of Dalí's Freudian
exploration of the subconscious that much of his art in recent years had
been, but rather a personal fantasy of which, he often said, he himself did
not know the explanation. The dark mood of the painting is set by the dark
starlit background and by the red door, above which are a number of orna-
ments. A woman stands by a safe while a soft watch marks the passing hours.

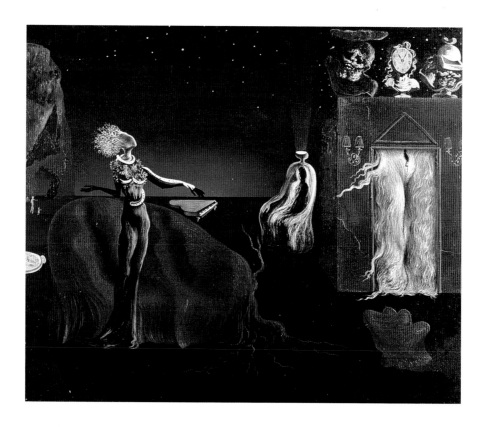

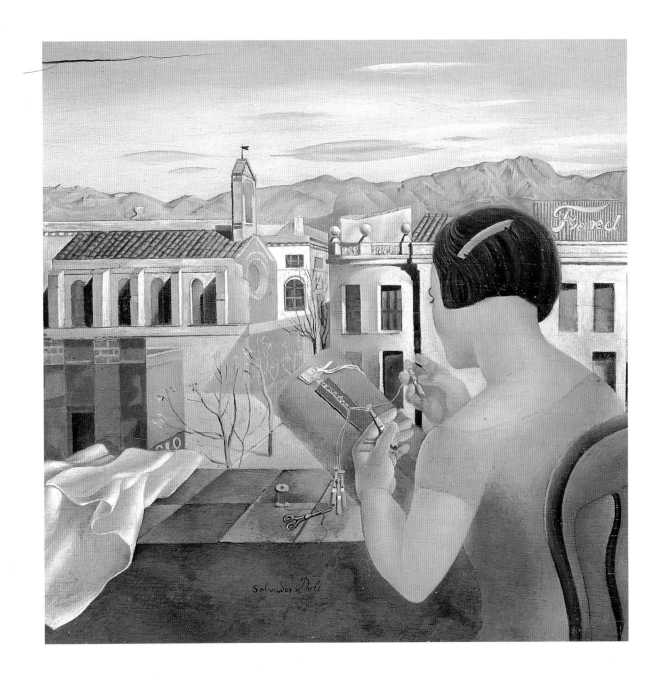

**Woman at the Window
at Figueras**

1926, oil on canvas; 24 x 25 in. (60.9 x 63.5 cm).

Collection J. Cashelles, Barcelona.

In his youth, Dalí painted many portraits of
his sister, Ana Maria. Here, she poses by the
window of a room in his family's house
in the small town of Figueras.

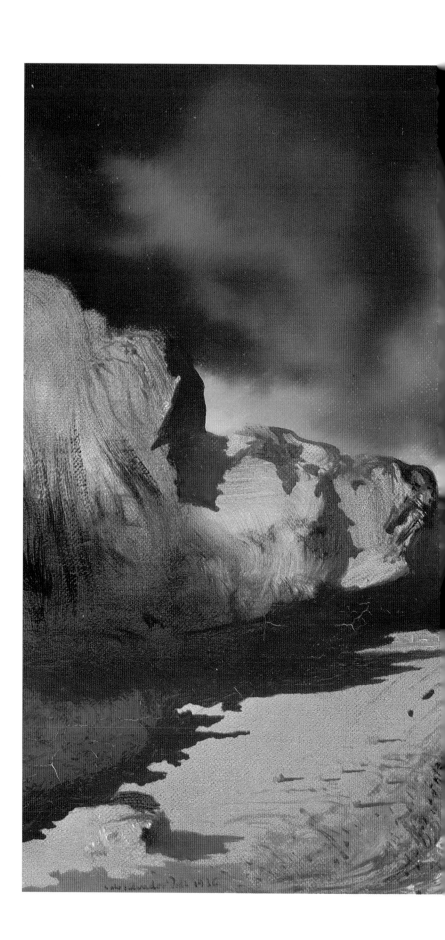

The Man with the Head of Blue Hydrangea

1936, oil on canvas; 6¹/₄ x 8¹/₂ in.
(16 x22 cm). Salvador Dalí
Museum, St. Petersburg, Florida.
Unlike his paintings of two
men with flower heads, this
painting, done in the year of
the Spanish Civil War, has a
more somber note. The road
leading into the distance is
strewn with rocks and the man
seems lost in the stony land-
scape, which is probably how
Dalí felt as he worried that the
circumstances of war might
deprive him of the Cadaqués
environment which was so es-
sential to his art and well-being.

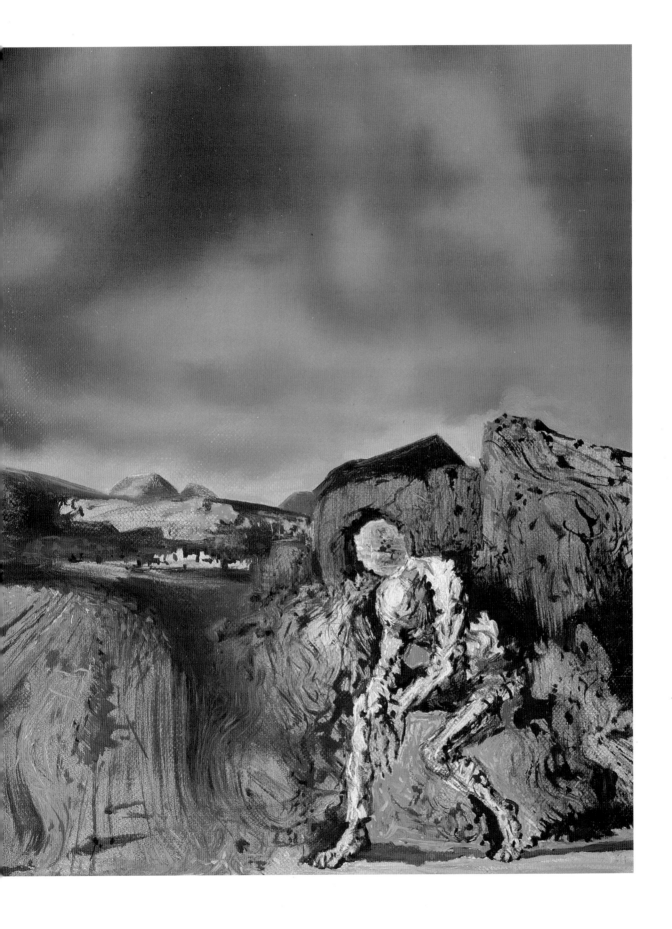

Harlequin

1927, oil on canvas; 74⅜ x 55⅛ in.

(189.8 x 140 cm). Museo d'Arte Contemporanea, Madrid.

Dalí's second one-man exhibition at the Delmau Gallery
in Barcelona (December/January 1926–27) included, among
other works, *Harlequin, Girl Sewing, Composition with Three
Figures (Neo-Cubist Academy)*, and *Landscape at Penya-Segats*.

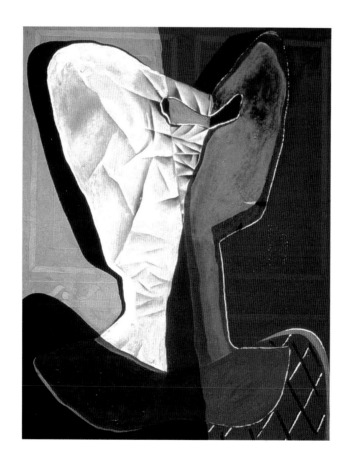

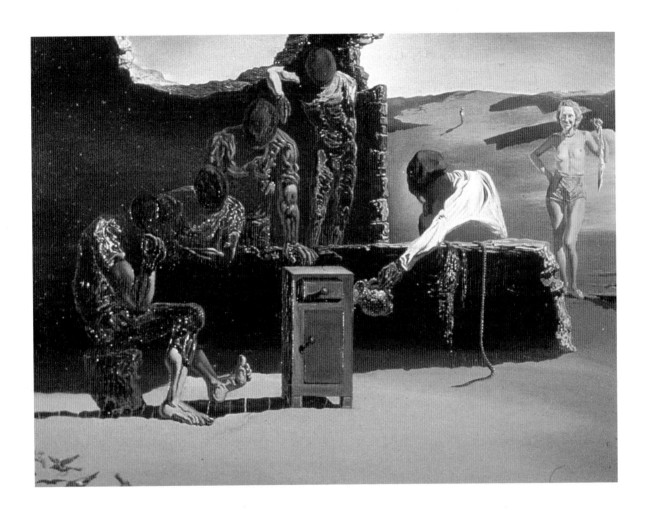

Cardinal, Cardinal!
1934, oil and gouache on panel; 6¹/₄ x 8¹/₂ in. (16 x 22 cm).
Munson Williams Proctor Museum, Utica, New York.
Ruined buildings often appear in Dalí's work as reminders of a
European culture which he saw as declining. In this painting, a
man with his back to the spectator looks at a spectral Gala
while other ambiguous figures hover round him, adding to a
general sense of past life and present desolation.

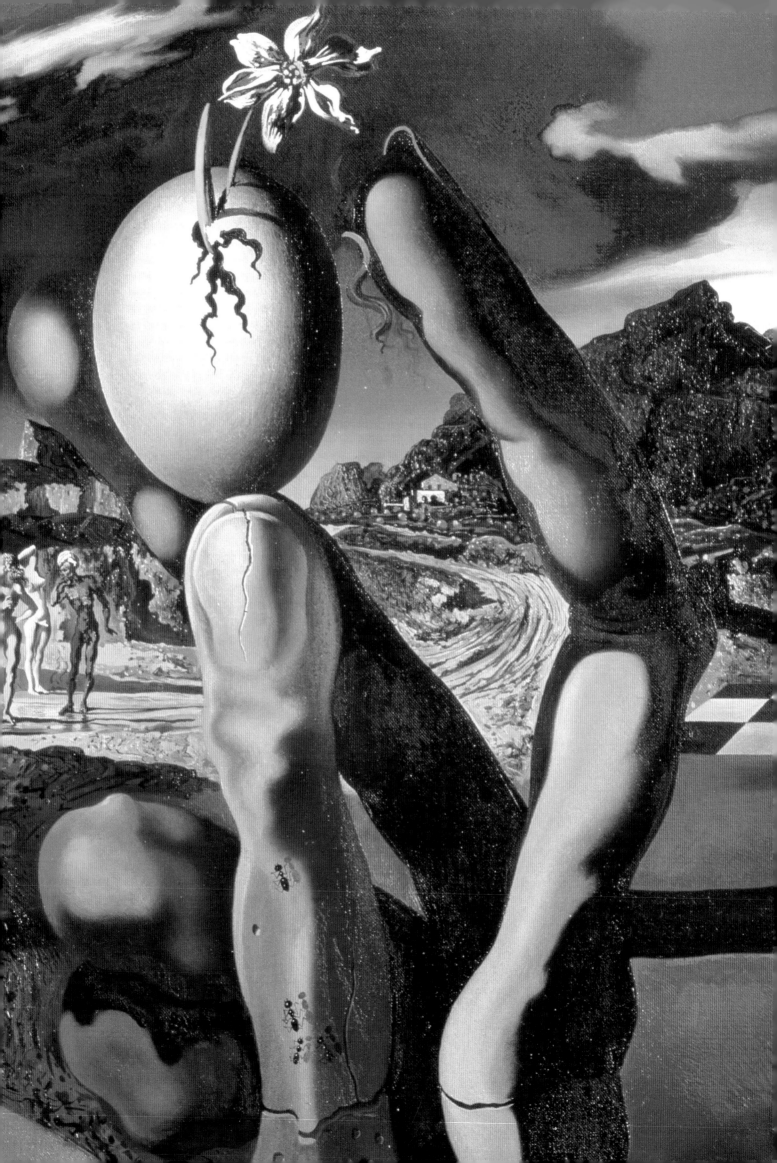

Paranoia and War

Characteristic of the great figures of modern art is a powerful belief that they possess a personal vision, and it is by this conviction that they imprint themselves upon the world's consciousness. Most have carried their conviction in a visual language of their own, building on contemporary painting techniques to develop an individual means of expressing ideas and feelings—without the necessity of a literary explanation.

This was not the case with Dalí who, after a brief skirmish with such techniques as Pointillism and Cubism as well as the style of his fellow Catalan Joan Miró, decided that what truly interested him was content and that the techniques of great masters such as Botticelli and Velázquez were satisfactory for what he wanted to say.

Yet what it was that he actually wanted to say remained, in a sense, a mystery as much to Dalí as to his public, though this did not detract from the feeling that he was making powerful statements, as powerful as those Velázquez had made about the court of Philip IV and his servants or those Turner had made about clouds and weather conditions. Dalí's route to artistic expression was via the liberation of ideas latent in the human mind, particularly his own, which was a wonderland of memory and experience, some real, some invented, and all of it transformed by the looking glass of his own phantasmagoric vision.

THE PARANOIAC-CRITICAL METHOD

Dalí labeled his new exploration of painting themes his paranoiac-critical method—a method (as well as an

The Metamorphosis of Narcissus

detail; 1937. Tate Gallery, London.
The fingers holding the bulb of a narcissus echo the limbs of the real Narcissus, on the left of the painting: this double vision is also a pun on the fact that Narcissus was in love with a nymph who was punished by being condemned to repeat the last words that anyone spoke to her: hence her name, Echo.

explanation) to access what he called irrational knowledge. To liberate hidden thoughts, the artist firmly believed, required the mind of a madman or someone who, because of his so-called madness, was not restrained by the guardian of rational thought—i.e., the conscious mind with its moral and rational attitudes. A person in the grip of delirium, Dalí argued, was not subject to constraints and thus it was necessary for him to be mad. However, Dalí assured his public, the difference between himself and a madman was that he was not insane, hence his paranoia was linked to a critical faculty.

This kind of paradoxical argument became fundamental to Dalí's work and created a sense both of positive statement and of ambiguity. The uncertainty stimulated the imagination of viewers who, accustomed to a world of orderly landscapes, portraits, or groups of classical nudes, were excited by the puzzle paintings with their frequent erotic and scatological references.

In a world that normally depended on comforting labels as crutches for reality, Dalí's approach was both an affront and a stimulus. The affront was caused not only by the sexual character of his work, with its references to castration, masturbation, and sodomy, but also to the art establishment due to his contempt for the progress in technical enlightenment which had thus far marked twentieth-century art.

The key to Dalí's world was Sigmund Freud, whose investigations into the subconscious sexual traumas of his patients opened wide a viewpoint into the human psyche as shocking and unbelievable as the one which Charles Darwin had given to the world half a century before. For Dalí, the exposure of the subconscious had three things in its favor: It provided new themes for painting, it allowed him to explore and explain some of his personal problems, and it was an explosive that would demolish the old order. Moreover, it had excellent publicity value.

His own first attempt to give the idea a tangible form was in *The Invisible Man*, which he began in 1929

Mae West's Lips Sofa

1936–37, wooden frame upholstered in pink felt; 35¼ x 83 x 31¼ in.
(92 x 213 x 80 cm). Victoria & Albert Museum, London.
This sofa was designed as part of the furnishings of an apartment inspired by Mae West's face and was the only item constructed at the time. Only one or two were made and became the property of museums, attracting a cinema-going public more aware of the fame of the actress than of Dalí's art.

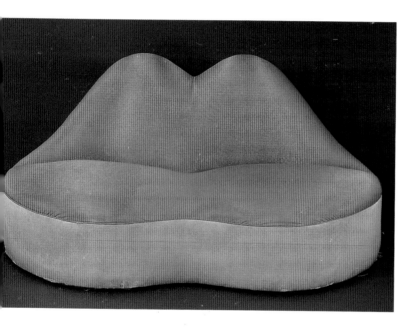

but did not complete until 1933. In this painting, a man's figure is hidden among a variety of architectural elements and other objects, phallic symbols, and Dalí's familiar evidence of fears of castration.

Dalí projected his idea of the existence of a whole world of the subconscious in his 1936 work *Suburbs of the Paranoic-critical City: Afternoon on the Fringes of European History*. In this painting, which at first glance seems to evoke a typical town, the disturbing elements do not immediately cause surprise or shock. The viewer soon begins to realize, though, that all the perspectives are disconnected, although this does not destroy the unity of the picture. The city is like a dream city of the subconscious, making perfect sense until the viewer observes it critically. Among its dreamlike features are the actions taking place in different parts, which, again, are totally unrelated but are real fragments in Dalí's memory. Gala holds up a bunch of

grapes, which are echoed in the fragmented horse and the classical building in the background; this, in turn, is echoed in the toy building in the open drawer of a chest of drawers. The whole—a complete but disjointed vision—is explained by the subtitle: it really is a midway of European history, exuding an atmosphere of nostalgia and regret.

OBJETS D'ART

Dalí's search for recognition in a society which was basically indifferent to art, especially modern art, brought out his natural flair for showmanship. It was at this time, around the mid-1930s, that the artist began to create those Surrealist objects which are among his best-known works. He created a bust out of a hairdresser's dummy on which he placed a French loaf and inkwell. Then there was the startling and provocative aphrodisiac dinner jacket hung with wine glasses. Other memorable works included *Lobster Telephone*, an "assemblage" made in 1936, and the striking *Mae West's Lips Sofa* (1936–37), basically a wooden frame with a pink satin cover.

Among all these attention-grabbing items, nothing grabbed more than a lecture Dalí gave at the London Group rooms in London's Burlington Gardens in July of 1936 as part of an International Surrealist Exhibition. He appeared for the occasion wearing a deep-sea diver's suit. The appropriateness of such dress for someone diving into the subconscious was applauded, but when Dalí's desperate gesturing finally alerted his hosts to the fact that he was suffocating through lack of air, applause turned to concern.

This was not exactly what Dalí had intended but it served to bring him to the attention of a wide public, which now had even more reason for attending the first Surrealist Objects Exhibition at the gallery in Cork Street, London, run by the American collector, Peggy Guggenheim. The incident may also have brought Dalí to the attention of the publishers of *Time*, who featured him on the magazine's cover at the end of 1936. Under a photograph (by Man Ray) of the artist was the line, "A blazing pine tree, an Archbishop, a giraffe and a cloud of feathers went out the window."

The meeting with Miss Guggenheim was Dalí's second contact with wealthy New York art patrons (previously, he had lectured on Surrealism at New York's Museum of Modern Art in 1935). They were soon to become his most enthusiastic supporters.

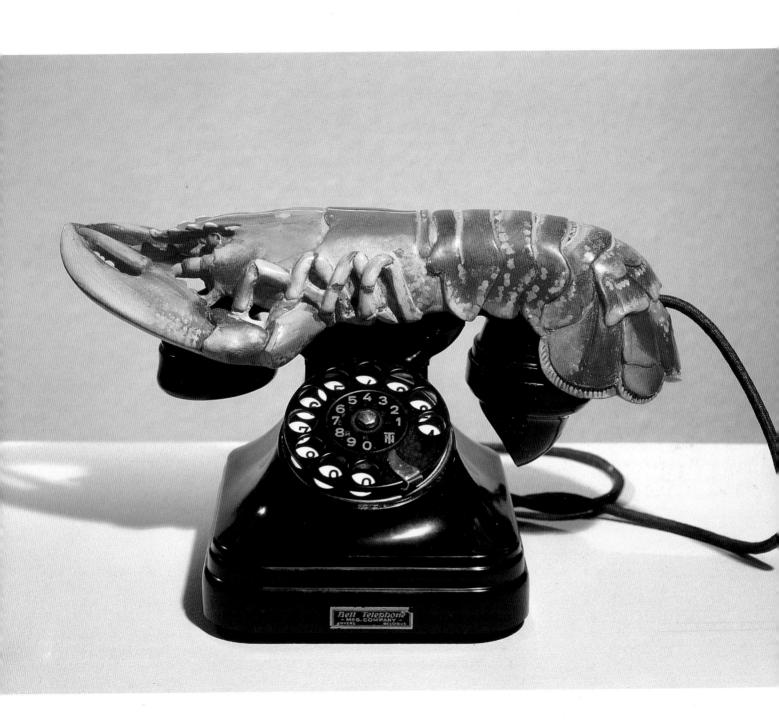

Lobster Telephone

1936, Surrealist object; 5³/4 x 6¹/2 x 11³/4 in. (15 x 17 x 30 cm). Tate Gallery, London.

Surrealist and found objects were not a new idea but Dalí did a great deal to make
them accepted as works of Surrealist art. This telephone with a plaster lobster
on the handpiece became an exhibit at the first London Surrealist exhibition in
1936. As part of the exhibition publicity, Dalí gave a lecture on the exploration
of the subconscious wearing a diving suit in which he nearly asphyxiated himself.

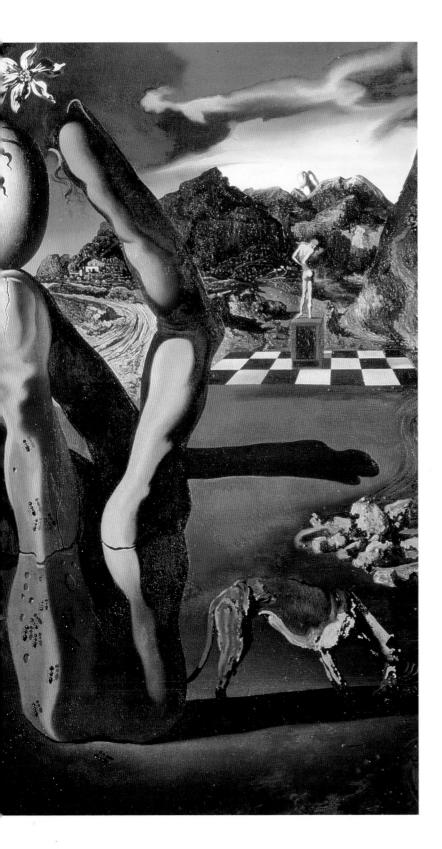

CELEBRITY SURREALIST

After his return from another visit to the United States in 1937, during which he visited Harpo Marx in Hollywood and collaborated on a film scenario, Dalí took part in another International Surrealist Exhibition, this time in Paris, contributing a Surrealist object which he called *Rainy Taxi*. This consisted of a taxicab with a naked mannequin (a shop window dummy) on the rear seat covered with live snails and water pouring onto it through holes in the roof. It caused a considerable outcry.

Dalí was now coming to terms with his status as an individual, a situation he signaled in his significant picture, *The Metamorphosis of Narcissus* (1936–37). This was his most effective double-image painting so far. At first glance the picture seems to represent the limbs of two figures in chiaroscuro against a conventional background. Then one notices that the limbs in the left half of the painting belong to a figure partly hidden in shade looking down into and reflected by a pool of water—the Narcissus image. On the right is a similar set of shapes, but this time the limbs are the fingers of a hand holding an egg, from the cracks of which grows a narcissus flower.

The Narcissus myth is here interpreted by Dalí as his own story of transformation via Gala. The self-absorbed young man, who had been preoccupied with masturbation and castration, has become a member of a normal sexual union, portrayed in the background of the painting in a style reminiscent of the active world of Renaissance pictures, even to a chessboard which seems to be borrowed from a Bellini painting.

The Metamorphosis of Narcissus

1937, oil on canvas; 20 x 30½ in. (50.8 x 78.3 cm). Tate Gallery, London.
This famously complex painting was shown to Sigmund Freud by Dalí. The famous psychoanalyst, then dying of cancer in London, commented that the painting improved his opinion of Dalí and of Surrealism. The Narcissus legend is cleverly exploited by the painter, who has created a deceptive double image of a figure and a hand holding a narcissus bulb.

Autumn Cannibalism

1936, oil on canvas; 25¼ x 25½ in. (65 x 65.2 cm). Tate Gallery, London.
Civil War, with families fighting against families, struck
Dalí as a form of cannibalism. Having often found inspiration
in food, Dalí created this composition in which two figures
are eating each other in accordance with good table manners.
In the background life, like nature, goes on despite the
human capacity for self-destruction.

ART AND CIVIL WAR

Dalí's return to Spain after the London Surrealist
Exhibition in 1936 had been interrupted by the out-
break of the Spanish Civil War, which began with a
coup against the Popular Government by General
Franco and his troops. The government moved to
Valencia and, after that city was threatened, to
Barcelona, Dalí's Catalan home land.

Dalí's horror at the likely fate of his country and its
people found expression in a number of paintings over
the years of the war. Among them was the dramatic
and horrifying *Soft Construction with Boiled Beans:
Premonition of Civil War* (1936), which expressed his
feelings in a way comparable to Picasso's ground-
breaking *Guernica*, though Dalí's painting is less sym-
pathetic to public taste because of its sexual
undertones.

This work is dominated by a fragment of a naked
woman with her breast cruelly squeezed by a gnarled
hand, and its actuality and realism horrified the public
much more than the symbolic abstractions of Picasso's
work. It is, nevertheless, a potent expression of the
horrors of war, symbolized by the simple boiled
beans—food of the poor—and behind the twisted
hand in the foreground a small bent figure, who is the
same simple man depicted by Dalí in *The Chemist of
Ampurdán in Search of Absolutely Nothing* and who sym-
bolizes the nihilism of modern life.

Although Dalí often expressed the thought that
world events such as wars had little to do with the
more eternal world of art, he was deeply distressed by
events in Spain and expressed his continuing horror in
Autumn Cannibalism (1936), a painting in which inter-
twined figures are feeding on themselves. The horror
is tempered by Dalí's use of the ever-present Cadaqués
landscape in the background as an expression of his
view that such things, even civil war, are transitory and
that life does goes on.

Dalí's last comment on the Spanish Civil War was
simply entitled *Spain* and was painted in 1938, when
the war was reaching its climax. This is a double-vi-
sion, paranoiac-critical work in which the figure of a
woman leans her elbow on a chest with one open
drawer from which hangs a red cloth; the top part of
her body is made up of smaller figures, most of them
in fighting poses, reminiscent of groups by Leonardo
da Vinci. The background is a desolate, sandy plain.

Many of Dalí's friends were victims of his home-
land's civil war. As was his habit with unpleasant
things, he tried not to think about them. One way of
accomplishing this was to anesthetize the mind, ide-
ally by sleeping. Such an attitude is illustrated in the
painting *Sleep* (1937), one of the artist's most power-
ful images. A disembodied head rests on frail crutches
which threaten to give way at any moment. On the

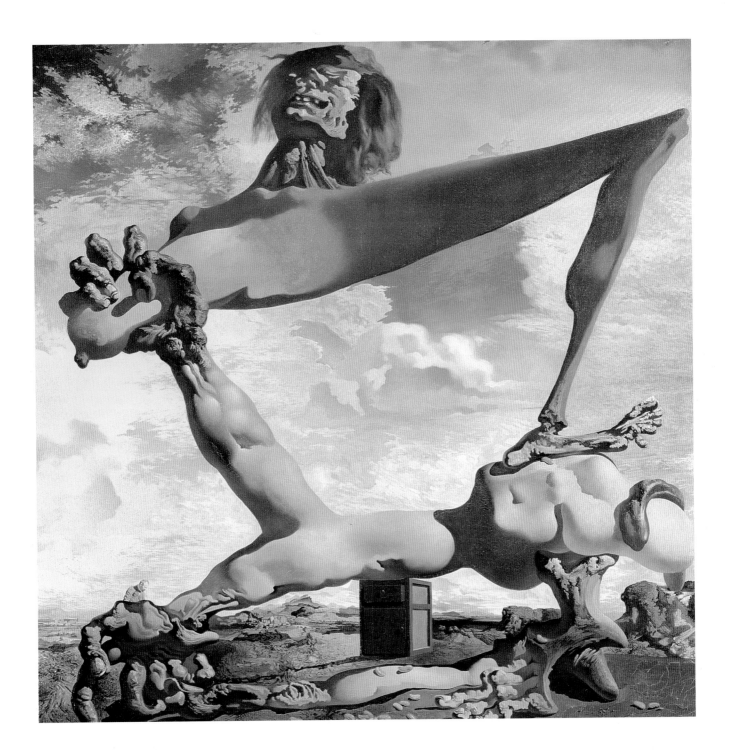

Soft Construction with Boiled Beans: Premonition of Civil War

1936, oil on canvas; 39 x 38½ in. (100 x 99 cm). The Louise and

Walter Arensberg Collection, The Philadelphia Museum of Art, Philadelphia, Pennsylvania.

Though he habitually ignored world political events, Dalí was deeply affected by the oncoming Civil War in Spain. In this painting, sex and horror are combined in a Dalíesque manner, with the boiled beans being used as a symbol of the simple people, such as the man behind the gnarled hand on the left, who are the real victims of such catastrophes.

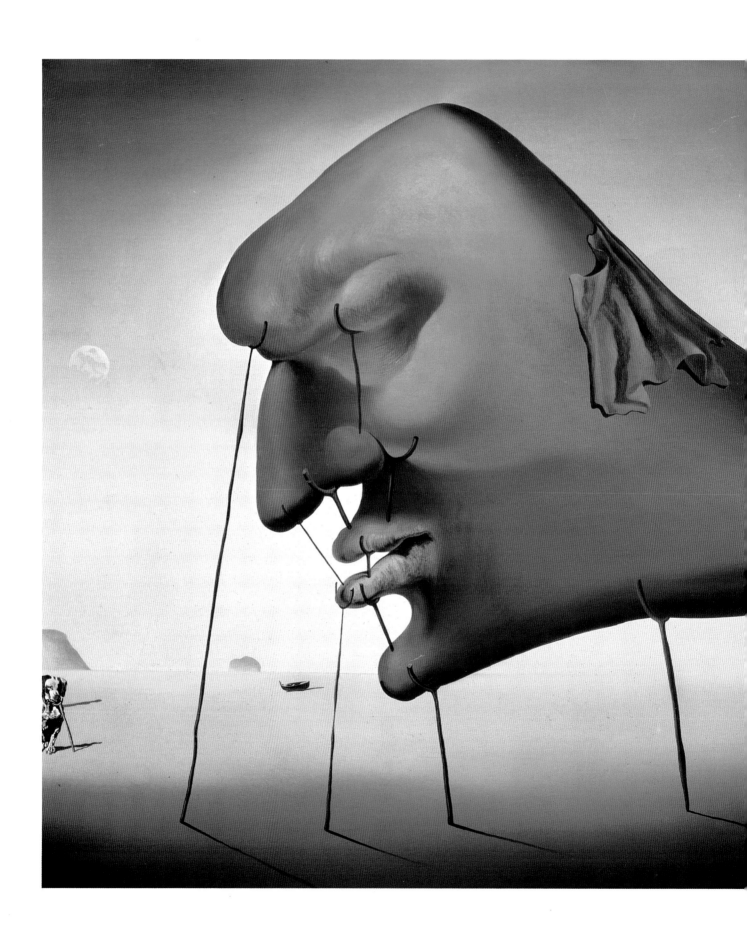

Sleep

1937, oil on canvas; 20 x 30½ in.
(51 x 78 cm). Private collection.
This image of sleep was one
of Dalí's most successful.
The identity of the head is
not difficult to divine: the
artist has portrayed himself.
Sleep was an important part
of life for Dalí: it not only
induced a forgetfulness of
the unpleasant side of life but
it was also the realm of the
unconscious in which dwelt
the paranoid fantasies which
were also hidden realities.

left of the painting is a dog, also held up by a crutch, and on the right, a village like one situated on the Costa Brava. The rest of the painting, except for a distant small fishing boat, is empty, symbolic of the painter's anxiety.

Another group of paintings revealing Dalí's worries about the clearly approaching world war included a telephone theme. *The Enigma of Hitler* (c. 1939) depicts a telephone and umbrella on an empty beach and refers to the abortive meeting between British Prime Minister Neville Chamberlain and Adolf Hitler. Both *The Sublime Moment* and *Mountain Lake*, painted in 1938, included (as well as a telephone) a crutch, a typical Dalí symbol of foreboding.

During the Spanish Civil War Dalí and Gala visited Italy to see the works of Dalí's most admired Renaissance painters. They also traveled to Sicily, a visit which inspired Dalí's *Impressions of Africa* (1938). The couple returned to France amid rumors of a European war, but found time to visit the United States again in the first part of 1939.

The further inevitably approaching horror dismayed Dalí, who left Paris for Arcachon, on the coast south of Bordeaux, shortly after the outbreak of war in September of 1939. From here, he and Gala went on to Lisbon where they met, among others fleeing the war, the celebrated designer Elsa Schiaparelli, for whom he had already designed dresses and hats, and the film director René Clair.

By the summer of 1940 Dalí and Gala had settled in the United States.

The Enigma of Hitler

c. 1939, oil on canvas; 20 x 31 in. (51.2 x 79.3 cm).

Museo Nacional Centro de Arte Reina Sofía, Madrid.

The telephone and umbrella which symbolized for Dalí the negotiations between Hitler and Chamberlain during the Munich crisis also appear in this painting, which includes a small photograph of the German dictator on a plate. The dark tone of the work speaks of Dalí's forebodings at the time.

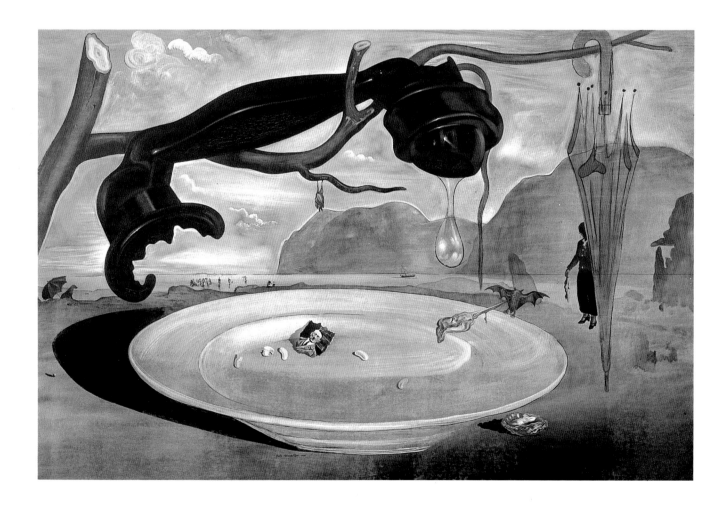

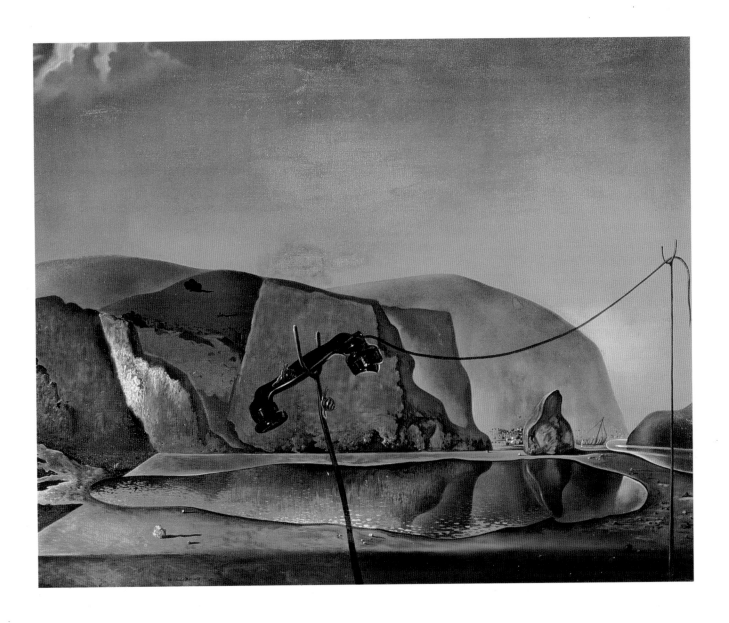

Mountain Lake

1939, oil on canvas; 28 1/2 x 36 in.
(73 x 92.1 cm). Tate Gallery, London.
"As an axiom of my oeuvre, I state
that there is no such thing as a lazy
masterpiece. Any creation requires
the tension of the entire being: talent
is not enough." —SALVADOR DALÍ

Anthropomorphic Echo

1937, oil on panel; 51½ x 20¼ in. (14 x 52 cm). Salvador Dalí Museum, St. Petersburg, Florida.

Dalí would seem to have filled this long horizontal canvas with figures representing two aspects of his own character. On the left is a town with two figures in the foreground, in the center a mounted St. George fights a dragon and, to the right, the figure of the skipping girl from earlier paintings appears again. The figures on the left seem to reflect the sinister, murkier side of Dalí's imagination while the others express heroic virtue and innocence, a side of the conservative, religious Dalí.

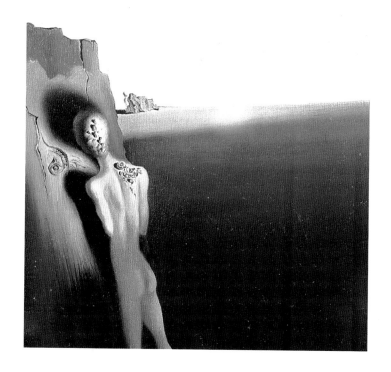

Solitude

1935, oil on canvas; 14 x 10⅝ in. (35.5 x 27 cm). Collection M. Filipacchi.
"While my painting is but a fragment of my cosmogony,
it is the most significant expression of my truth. Decipher!
Decipher! Then you will experience the vertigo of the
human absolute." —SALVADOR DALÍ

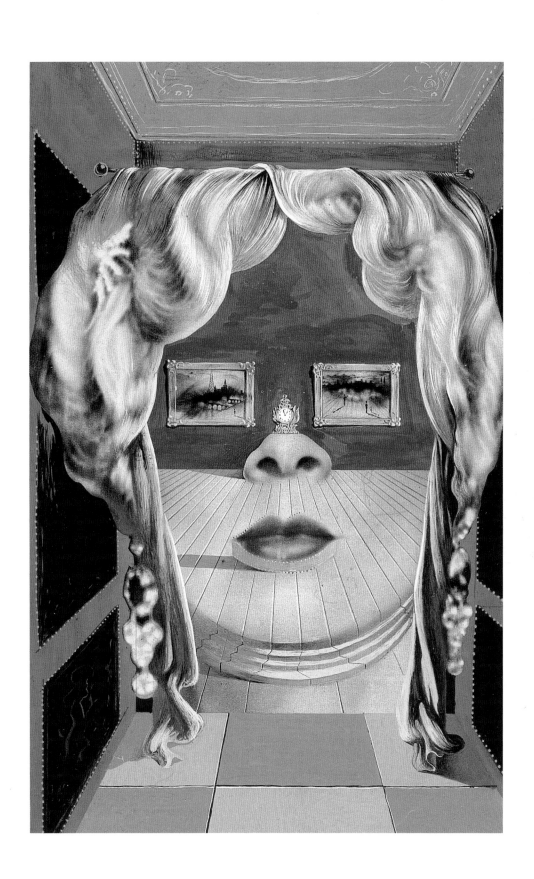

Mae West's Face which May Be Used as a Surrealist Apartment
1934–35, gouache on newspaper;
12 x 6½ in. (31 x 17 cm).
The Art Institute of Chicago,
Chicago, Illinois.
This was one of the "joke" ideas that Dalí liked to make from time to time. The sketch was intended to become a full-size, three-dimensional apartment shaped like the face of the 1930s actress famed for her daring and sexy jokes. It was not constructed until the Gala-Salvador Dalí Museum was opened in Figueras on September 28, 1974.

Morphological Echo

1936, oil on panel; 12 x 12¾ in. (30.5 x 33 cm). Salvador Dalí Museum, St. Petersburg, Florida.
This scene with a tablecloth—its fragments and objects echoed in
the objects which are either in the sky or on a vast plain—is a clever
piece of Dalí *trompe l'oeil*. The objects seem to be not so much
realities as echoes of each other in a world of ambiguous dimensions.

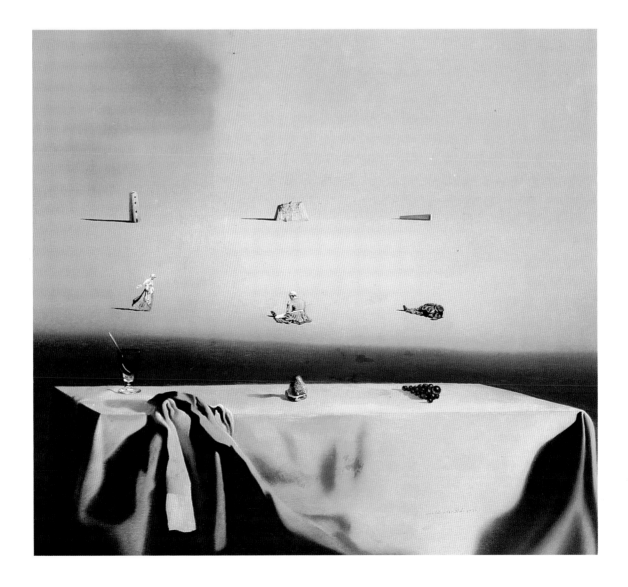

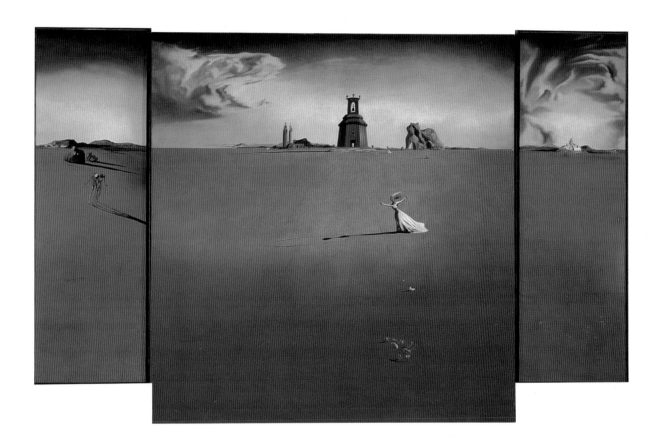

Landscape with a Girl Skipping

1936, oil on canvas; 114¼ x 109¼ in. (293 x 280 cm). Boymans-van Beuningen Museum, Rotterdam.
The skipping girls in this large triptych are similar to ones in other Dalí paintings and were inspired by the bell in the tower at Dalí's school in Figueras and also by the daughter of Dalí's friend, Pichot. The central panel also shows the classical building with a tower which was another memory of his youth.

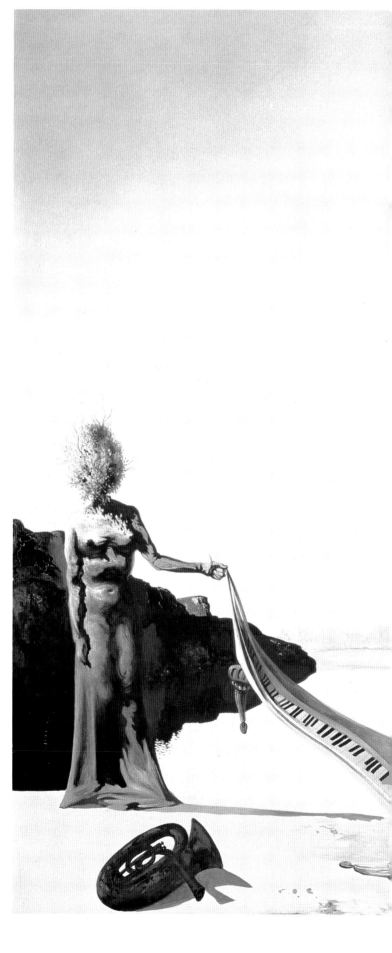

Three Young Surrealist Women Holding in Their Hands the Skins of an Orchestra

1936, oil on canvas; 21 x 25 ⅓ in. (54 x 65 cm). Salvador Dalí Museum, St. Petersburg, Florida.
The appearance of musical instruments in Dalí's paintings suggests that he was probably not a lover of music, for their use is often in an unpleasant context. In this painting, a whole orchestra is skinned while in other paintings pianos are sodomised or used to express Dalí's indifference to Lenin's revolutionary theories.

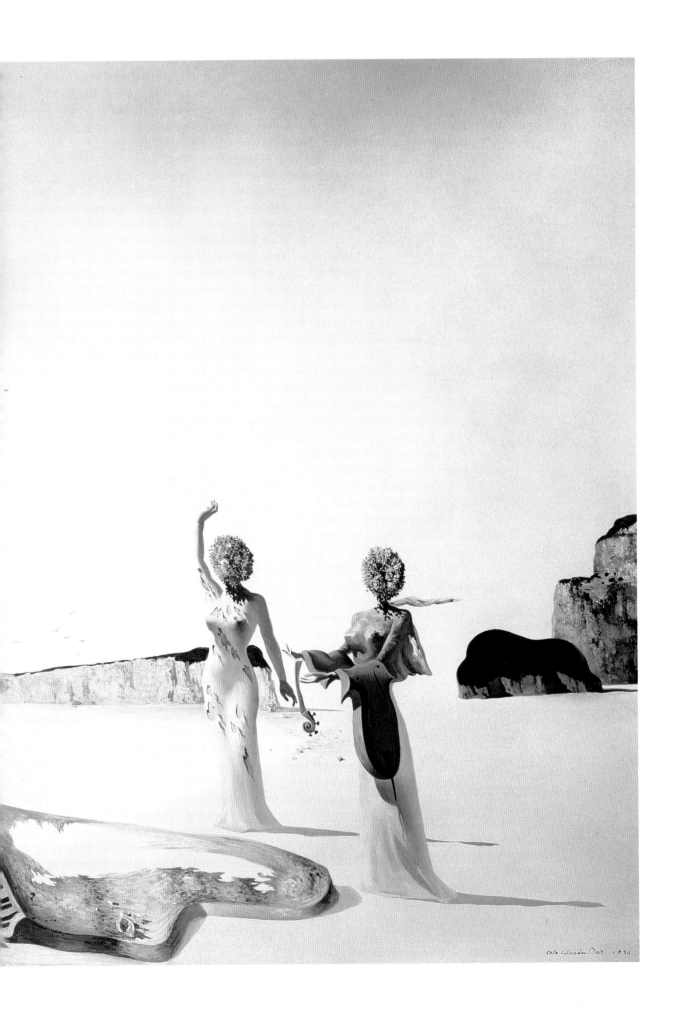

Paranoia

1936, oil on canvas; 14³/4 x 18 in. (38 x 46 cm). Salvador Dalí Museum, St. Petersburg, Florida.
This almost monochrome painting, with its gloomy blue tone, expresses
the down side of Dalí's paranoiac delusions. The headless woman with her
breasts covered in a cloth and the figures receding into the distance have a
dreamlike and nightmarish quality. The painting was done during a year of
great creativity in which Dalí's spirit often swung from joy to melancholy.

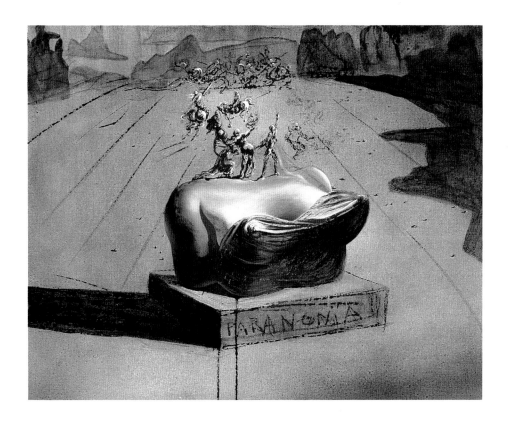

The Burning Giraffe

1936, oil on panel; 13¹/2 x 10¹/2 in. (35 x 27 cm). Kunstmuseum Basel, Basel.
The burning giraffe is not the main figure in this painting, though it
became one of the Dalí images that imprinted themselves on the
public's mind. The elongated female figures suggest Dalí's work for
fashion magazines and are cursorily dealt with. The use of the female
whose body contains desk drawers was already a popular Dalí icon.

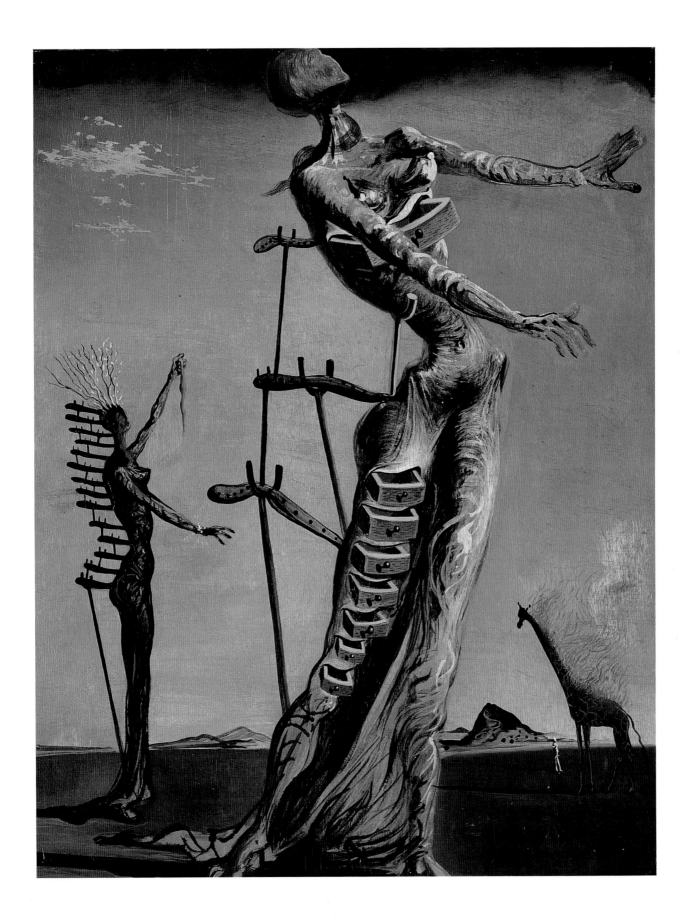

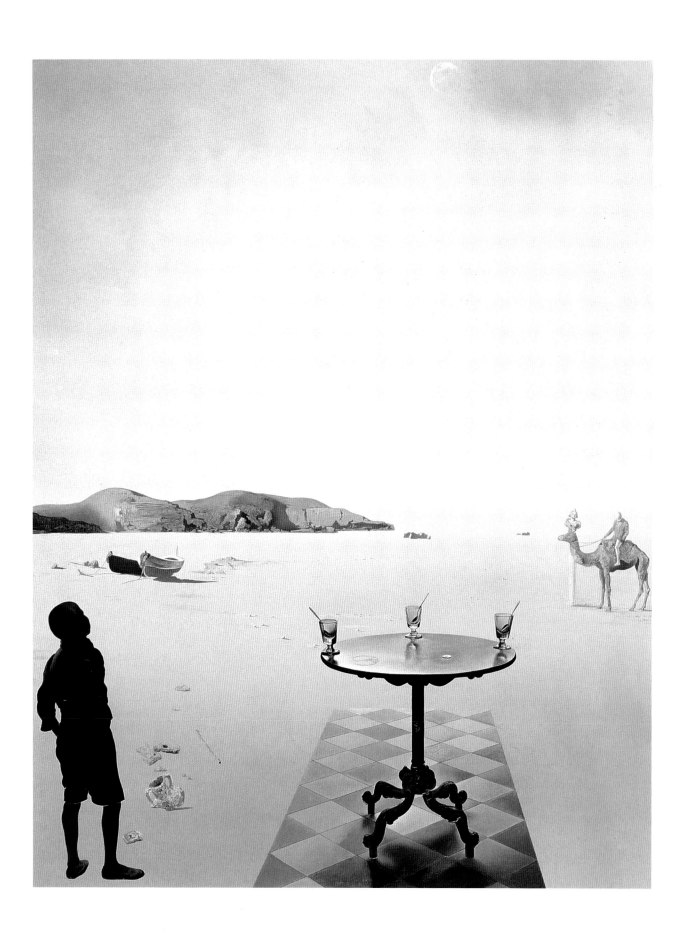

Forgotten Horizon

1936, oil on mahogany; 8 ⅞ x 10½ in. (22.5 x 26.6 cm). Tate Gallery, London.

Although in his later years Dalí was often an embarrassment to some critics, art historians, and museum directors, *Forgotten Horizon* was eagerly acquired by the Tate Gallery in London upon the sale of the Edward James collection.

Sun Table

1936, oil on panel; 23½ x 18 in. (60 x 46 cm). Boymans-van Beuningen Museum, Rotterdam.

The goblets on the table suggest absent persons, perhaps a memory of those who shared this table with Dalí at the Café de Casino at Cadaqués. The idea of people who are both present and absent appealed to Dalí and is the theme of most of his double vision paintings, where faces appear and disappear as one looks at them. Like other paintings evoking sea, sky, and vast space, this was inspired by the Costa Brava coast which was Dalí's true and spiritual home.

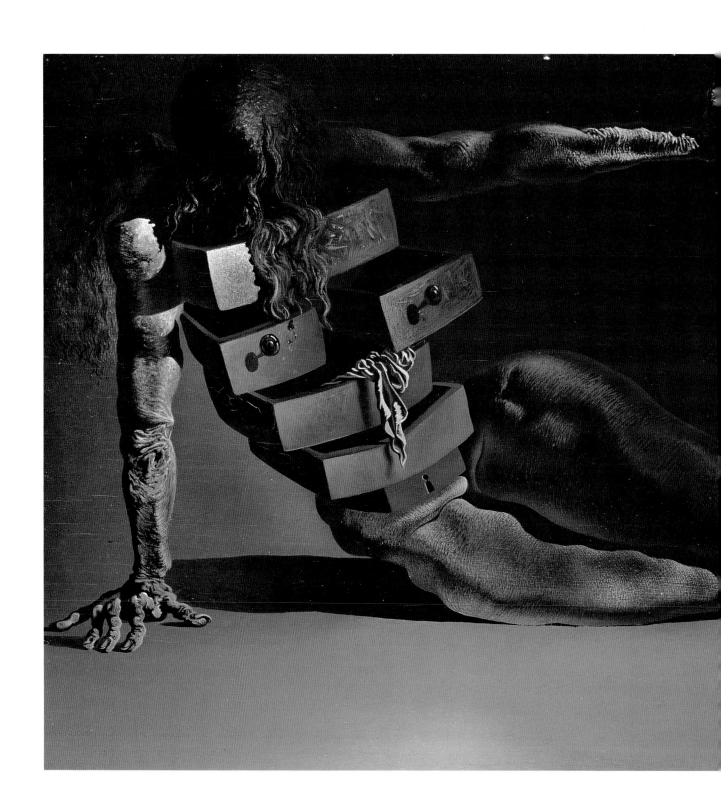

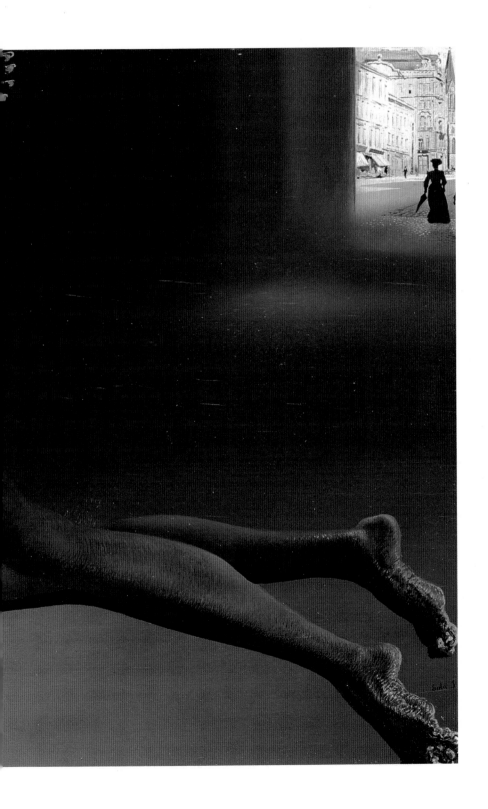

The Anthropomorphic Cabinet

1936, oil on panel; 10 x 17¼ in.
(25.4 x 44.2 cm). Kunstsammlung
Nordrhein-Westfalen, Düsseldorf.
The year 1936 was a particu-
larly productive one for
Dalí, who had taken a house
at Port Lligat, near Cadaqués.
His appearance at the Sur-
realist Exhibition in London
and his contract with Edward
James to sell him his most
important work helped
to make his bizarre images,
such as women with furniture
drawers, well known.

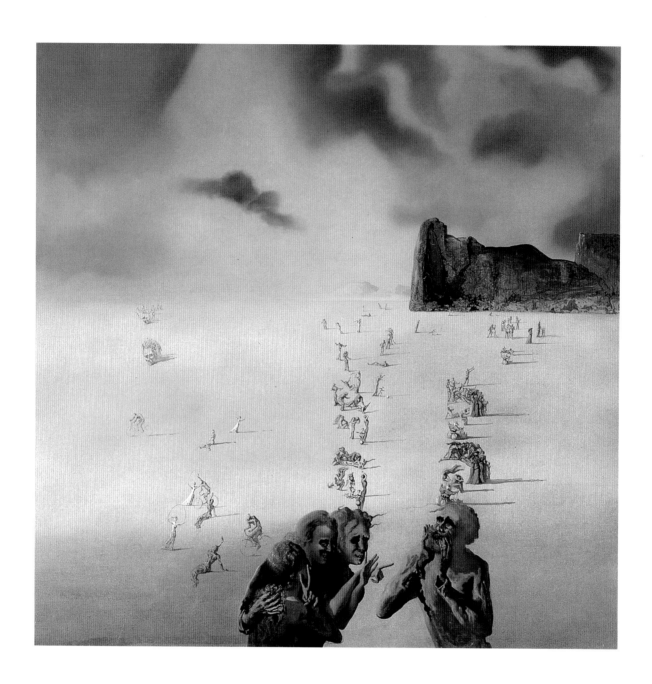

**Premonition of Paranoiac
Perspectives through Soft Structures**

1936–37, oil on canvas; 25½ x 25 ⅓ in. (65.5 x 65 cm). Kunstmuseum Basel, Basel.
This is a curiously blank landscape in which the receding figures
have an elusive but potent impact. Like a stage set with actors who will
not say their lines, the painting has an obsessive presence which
bears out the idea of corruptibility and obsession suggested by the title.

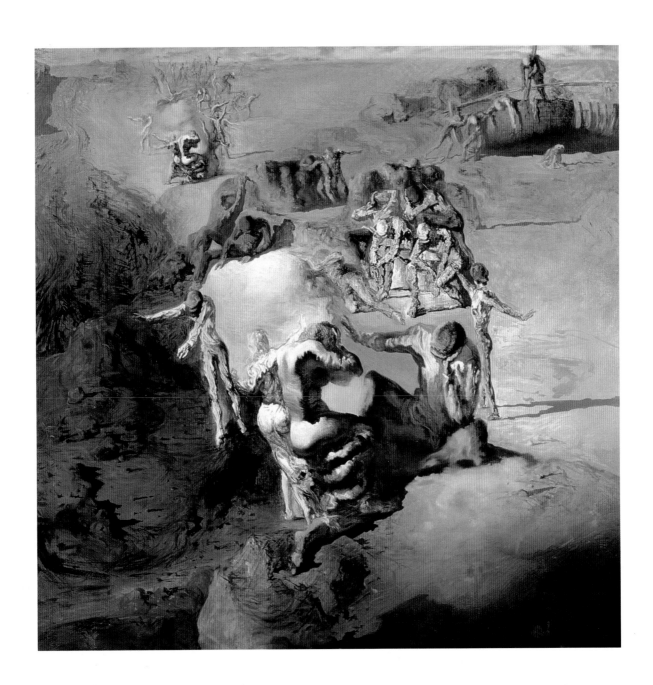

The Great Paranoiac

1936, oil on canvas; 24 x 24 in. (62 x 62 cm). Ex-Edward James Foundation, Sussex.
Heads made up of fruit had been an artistic whimsy long before Dalí
created this clever head made of bodies. The drawing shows Dalí in his
best Leonardo da Vinci style. The idea of heads made of bodies was
carried further by Dalí when he arranged a group of nude women to suggest
a skull. The result was photographed by his friend Phillipe Halsman.

Impressions of Africa

1938, oil on canvas; 35½ x 45¾ in. (91.5 x 117.5 cm).

Boymans-van Beuningen Museum, Rotterdam.

The nearest that Dalí ever got to Africa was
Sicily, and this painting was made in Rome. The
inspiration came from the work of Raymond
Roussel, a writer who had committed suicide in
Sicily. The painting is a *tour de force* of Dalí's drafts-
manship, particularly striking in his foreshortened
hand and the double-image Gala behind him.

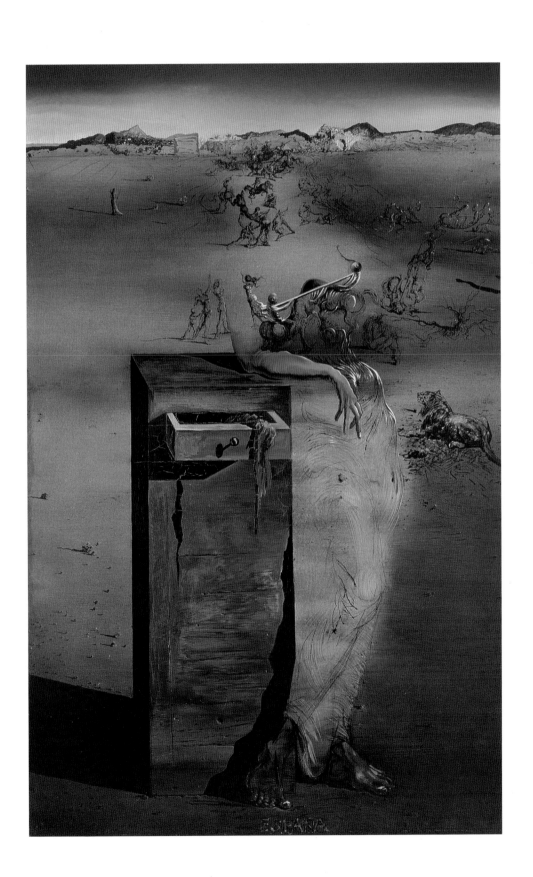

Spain

1938, oil on canvas;
35¾ x 23½ in.
(91.8 x 60.2 cm).
Boymans-van Beuningen
Museum, Rotterdam.
This was Dalí's last
word on the Spanish
Civil War, so the
painting's air of sad
inevitability is not
surprising. Dalí's home
province, Catalonia,
was about to crumble
under the assault of
Franco's troops, an
event which Dalí has
expressed in the shad-
owy female figure
leaning on an empty
and broken piece of
furniture while fighting
soldiers, drawn in
a Leonardo-esque
style, recede behind it.

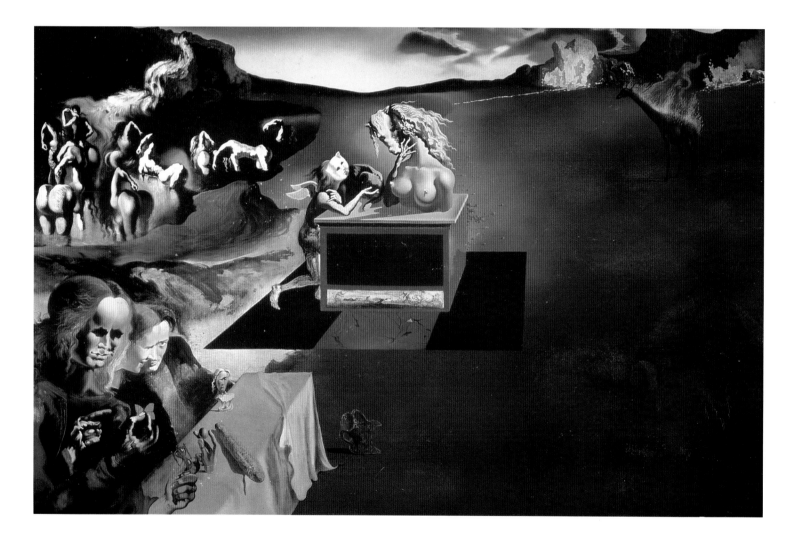

The Invention of Monsters

1937, oil on panel; 20 x 30½ in. (51.2 x 78.5 cm). The Art Institute of Chicago, Chicago, Illinois.
Into this rocky landscape Dalí has introduced many of the "monsters"
of previous works: the woman with a horse's head, the skipping girl,
the transparent nudes. The only non-monster, Dalí claimed, was
the ghostly dog in the right-hand bottom corner. On the left,
Dalí sits with Gala and their Pre-Raphaelite double image.

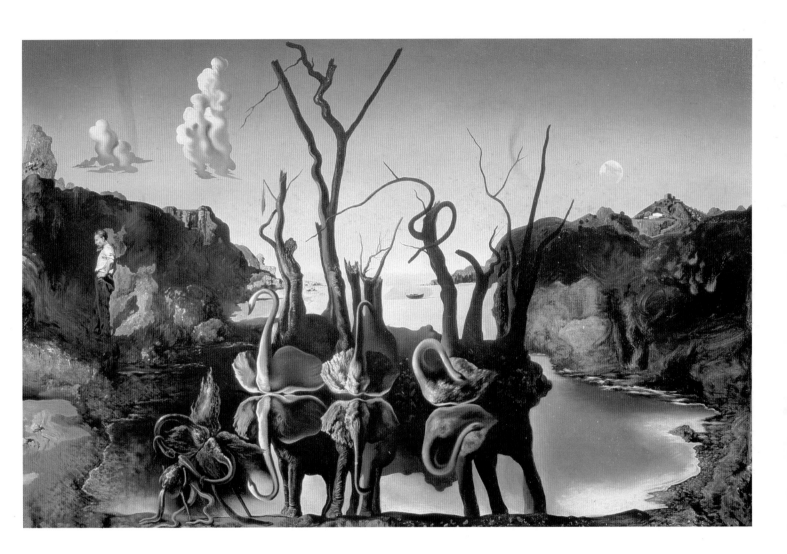

Swans Reflecting Elephants

1937, oil on canvas; 20 x 30 in. (51 x 77 cm). Cavalieri Holding Co. Inc., Geneva.
Swans and elephants come into an eye-titillating pattern in this
typically Dalí *trompe l'oeil* which can be looked at either way up.
The trees play their natural role or are elephants' legs and the swans' wings
become elephants' ears. The background is derived from the hills around
Dalí's home, though there is also a suggestion of Italy in the villages.

The Endless Enigma

1938, oil on canvas; 44¹/₂ x 56¹/₈ in. (114.3 x144 cm).

Museo Nacional Centro de Arte Reina Sofía, Madrid.

In the period between the start of the Spanish Civil
War and the outbreak of World War II, Dalí painted
a number of mysterious landscapes potent with meaning
and emotional content. The coloring is dense; in the
distorted globe which stretches out in the foreground is seen
Dalí's distress at having to leave his safe haven of Cadaqués.

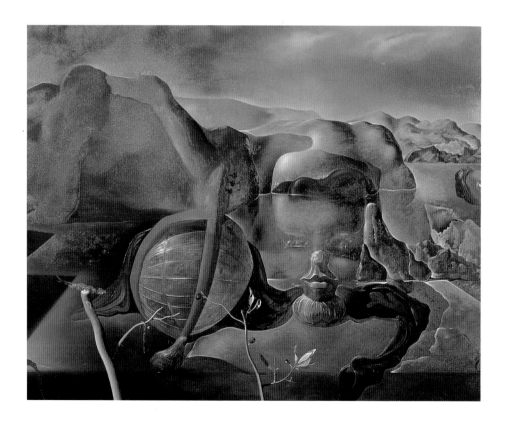

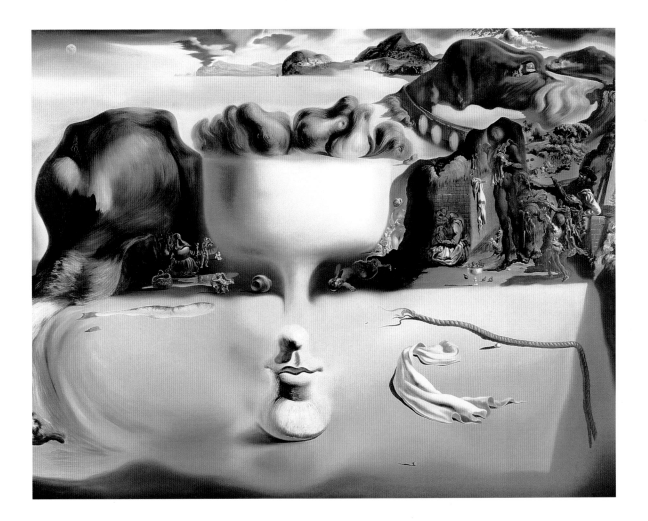

The Apparition of Face and Fruit Dish on a Beach

1938, oil on canvas; 44¹/2 x 56 in. (114.5 x 143.8 cm). The Wadsworth Atheneum, Hartford, Connecticut.
In this painting, which is similar to another painted in 1938 (which included
the face of Lorca, who was shot in 1936), Dalí has combined a beach, a face, a
fruit bowl, a dog, and a distant landscape in a cleverly deceptive composition
which could almost be seen by a casual spectator as a conventional landscape.

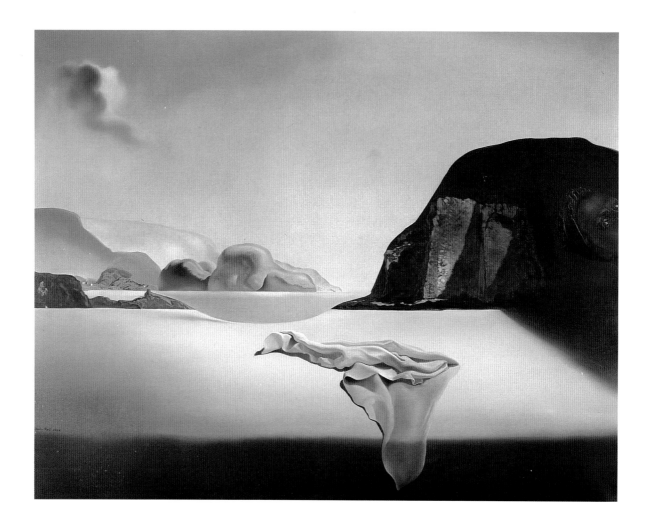

The Transparent Simulacrum of the Feigned Image

1938, oil on canvas; 28½ x 35⅞ in. (73.5 x 92 cm). Albright Knox Gallery, Buffalo, New York.
The brightly lit foreground on which there appears to be a cloth is like
the floor of a stage, empty except for a rag. The background is the familiar
one of Dalí's home on the Costa Brava, and the air of unreality is in
keeping with the painter's lifelong feeling that nothing is what it seems.

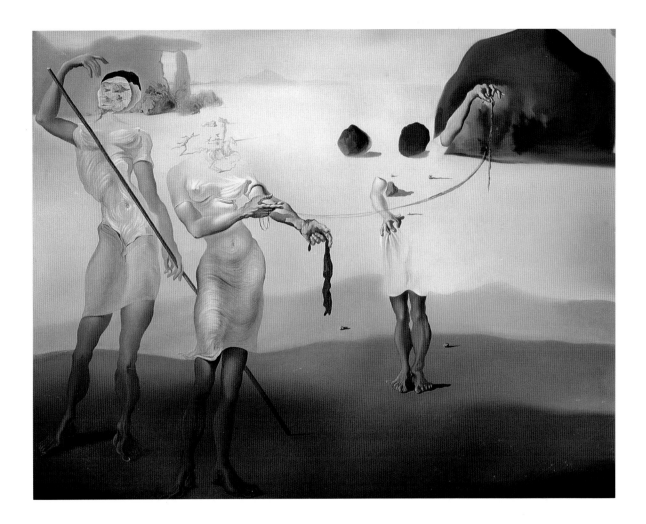

Enchanted Beach with Three Fluid Graces

1938, oil on canvas; 25 ⅓ x 31½ in. (65 x 81 cm). Salvador Dalí Museum, St. Petersburg, Florida.
The three fluid graces here seem not unlike the three Surrealist women holding
the skins of an orchestra that Dalí had painted in 1936, though now they are in
a less destructive mood. This is, in fact, a Dalí image of the golden age of
Classicism which he much admired and hoped to emulate in a modern fashion.

"Avida Dollars"

The "Avida Dollars" anagram, made from Salvador Dalí's name in 1941 by André Breton, was intended as a sneer at Dalí's money-making activities, but there was more than a dash of envy in it, inspired by Dalí's growing success beginning in 1936 and the phenomenal welcome he received in the United States from wealthy patrons and the general public alike.

In European art circles Dalí was not regarded as a serious contender for the aesthetic crown, immersed as he was in esoteric artistic theories, but in the United States, where art was still carried on in a traditional manner and where traditional European art was sought after by the millionaire barons of commerce, Dalí was greeted with enthusiasm. His paintings, though puzzling in content, were visually accessible for the objects in them were identifiable, and his brash persona, resented in Europe, was accepted in the United States, which prided itself on its frank, tough, larger-than-life frontier characters and showmen.

AMERICAN DREAMS

Dalí and Gala had left Europe with reluctance but they were soon comfortably settled in Fredericksburg, Virginia, at Hampton Manor, home of Caresse Crosby, the avant-garde publisher. Here, Gala set about making Dalí feel at home by commandeering the library and ordering up painting materials from the nearby town of Richmond; her efforts were observed and later recorded by the writer Anaïs Nin, who was also present.

Slave Market with Disappearing Bust of Voltaire

detail; 1940. Boymans van Beuningen Museum, Rotterdam.

Dalí used many *trompe l'oeil* effects to entertain the viewer. This is his most effective, with the head of Voltaire, as carved by Houdon, also being two women in Dutch costume. The effect is such that it is difficult to see both images simultaneously.

After a year with Mrs. Crosby, Dalí and Gala moved across the United States to Monterey, California, near San Francisco, which became their main base, though they spent a great deal of time living in expensive luxury in New York. It would be eight years before Dalí and Gala returned to Europe, years in which Dalí made his fortune—though, many critics agree, it was made at the expense of his reputation as an artist.

In the world of the art intelligentsia Dalí's reputation had never been high. Apart from his outrageous behavior, which may have had a publicity value for him but was regarded as mere showmanship by art lovers, Dalí worked outside existing trends in art. Broadly speaking, most artists as well as art lovers saw the art of their time as a search for a new language which would express contemporary society and all the new ideas that went with it. The old techniques, whether of literature, music, or the plastic arts, were no longer seen as suitable for the twentieth century.

To many people, Dalí's traditional style of painting did not seem as relevant to the struggle to find a new painting language as did the work of such twentieth-century masters as Picasso and Matisse. Nevertheless, Dalí did have a following among European art lovers, especially those interested in the Surrealist movement, who saw in his work a valid form of expression of the hidden elements of the human spirit.

AMERICAN INCIDENTS

Dalí's involvement with an increasing number of commercial projects during his years in America (including the theater, ballet, jewelry, fashion, and even a self-promoting newspaper which ran to only two issues) made him appear to be more of an entertainer than a serious artist dedicated to the exploration of the means of expression. Although he became ever more famous, Dalí began to lose, in Europe at least, the support of art critics and historians, on whom an artist's reputation rests in his or her own lifetime.

From his safe havens in Virginia and then in California, Dalí began his triumphal progress in the art world of a new continent, where American friends were now ready to help further his career. One of his early assignments had been to design a pavilion called *Dream of Venus* for the New York World's Fair in 1939. The pavilion was to have had an indoor pool with mermaids and on the facade Dalí planned a figure of Venus, after Botticelli, but with the head of a cod or similar fish. The fair's management objected and the pavilion was never built, but Dalí had been given the opportunity to publish his first American manifesto *Declaration of the Independence of the Imagination and of the Rights of Man to his own Madness.*

Before the World's Fair incident there was the Bonwit Teller incident. Dalí was commissioned to design window displays for the Bonwit Teller department store in New York. Dalí's displays were in his inimitable, extravagant style and included a black satin bath and a canopy made out of a buffalo's head with a bloodstained pigeon in its mouth. This attracted so much public attention that it held up transit on the Fifth Avenue sidewalk. The store's management had the display altered, which so annoyed Dalí that he overturned the bath, causing it to break the plate-glass window, through which Dalí then stepped, to be arrested by the New York police.

There was a suspended sentence for Dalí and so much publicity that the current show of his work at a New York gallery was a sell-out. Such happenings, while shocking some, proved good publicity among the public in general, who saw Dalí as a champion of that individual freedom for which the United States prided itself and which, he declared, was to be found only in America (i.e., not in Europe).

When some in the media questioned Dalí's sanity and the value of his clowning, he took advantage of the challenge. Replying to an article in *Art Digest* inquiring whether he was mad or just a good businessman, he said that he did not know himself where the deep, philosophical Dalí began and where the loony and preposterous Dalí ended.

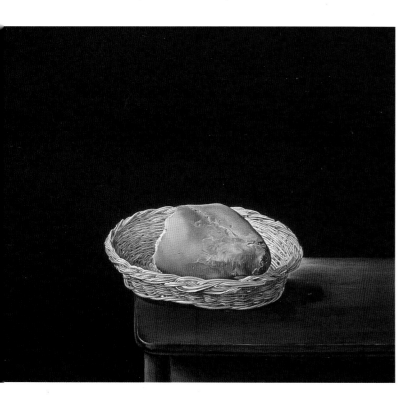

Basket of Bread — Rather Death than Shame

1945, oil on panel; 12⅞ x 14¾ in. (33 x 38 cm).
Fundacion Gala-Salvador Dalí, Figueras.
Bread had a religious connotation for Dalí, as indeed it has for many people in Latin countries. It is the staff of life and the body of Christ. In most of his bread still lifes, Dalí took few liberties with the object and painted in a traditional way and with the technical mastery that was characteristic of his work at its best.

Galarina

1944–45, oil on canvas; 25 x 19½ in. (64.1 x 50.2 cm).
Fundacion Gala-Salvador Dalí, Figueras.
Dalí's adoration of his wife Gala, though described by him as passionate and sexual, did not prevent her having other lovers throughout their life together. Dalí offered his own impotence as an explanation for this, though whether this was true or another fantasy is anyone's guess.
Studies for this painting by Dalí date back to 1941.

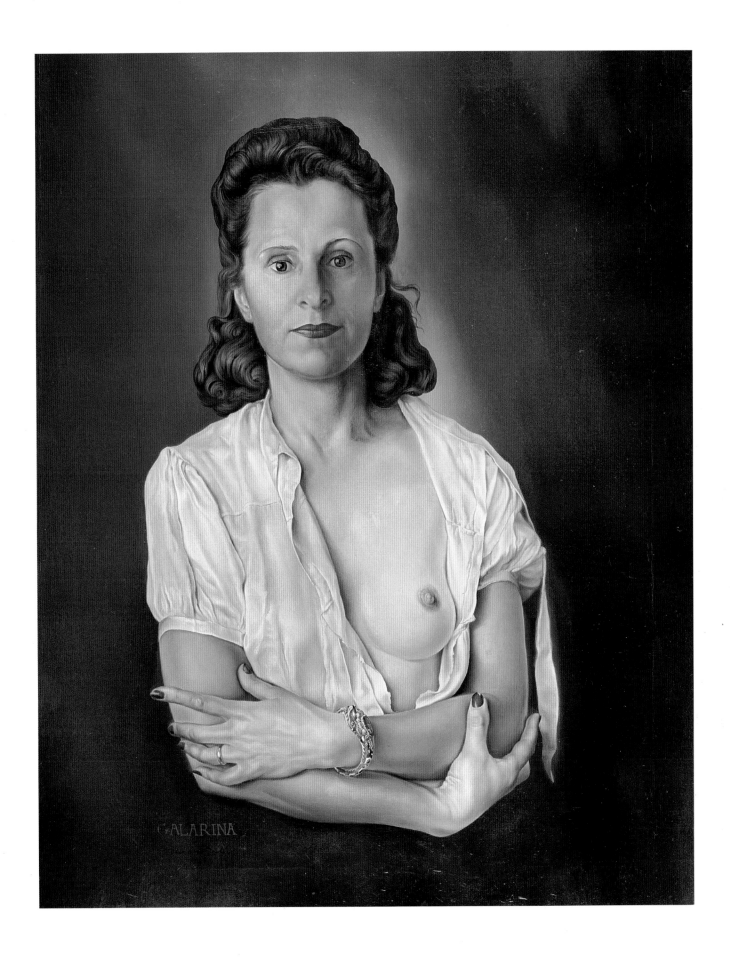

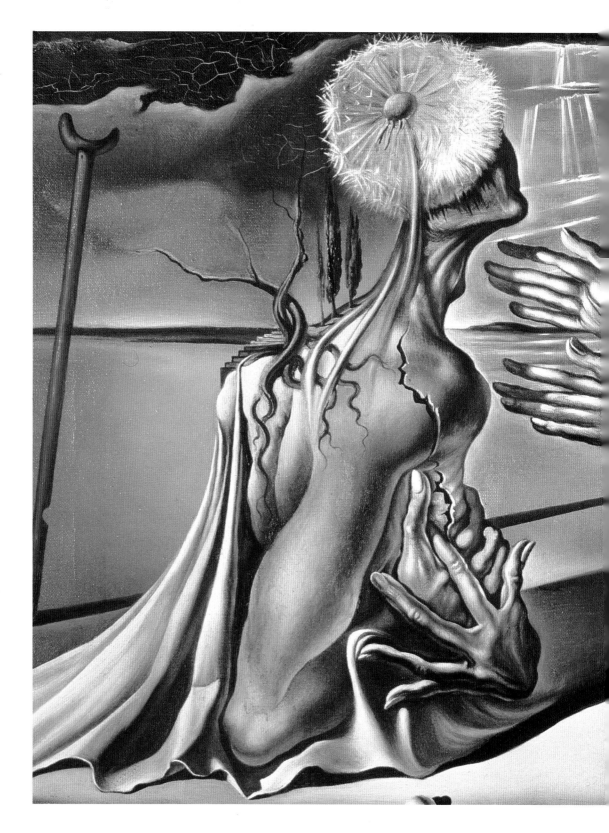

**Design for the
Set of the Ballet
*Tristan and Isolde***
*1944, oil on canvas;
10½ x 18⅞ in. (26.7 x 48.3 cm).
Fundacion Gala-Salvador
Dalí, Figueras.*
The two half figures
cracking under stress
are symbolic of the
tragedy of Tristan and
Isolde. The libretto,
initially written by Dalí,
eventually became the
ballet *Bacchanale* by
Maurice Béjart, put on
by the Marqués de Cuevas
in New York in 1944.

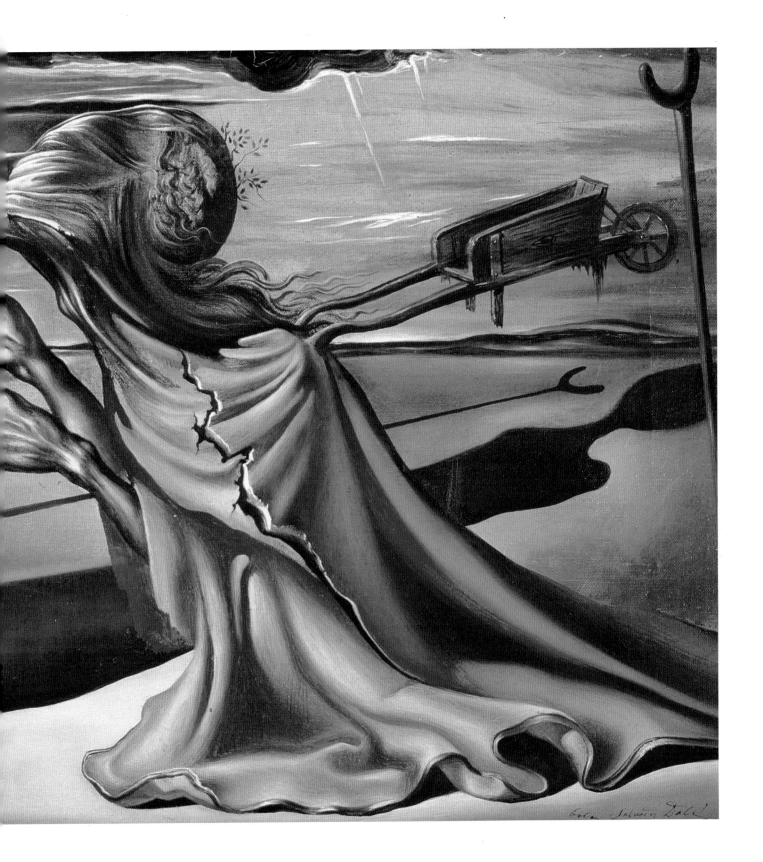

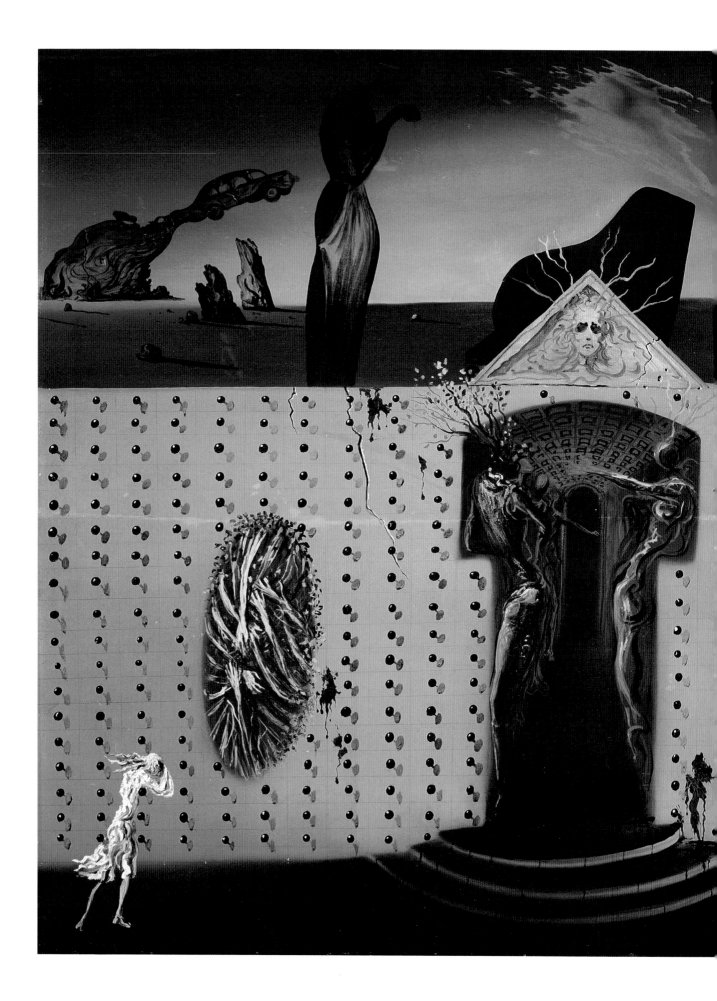

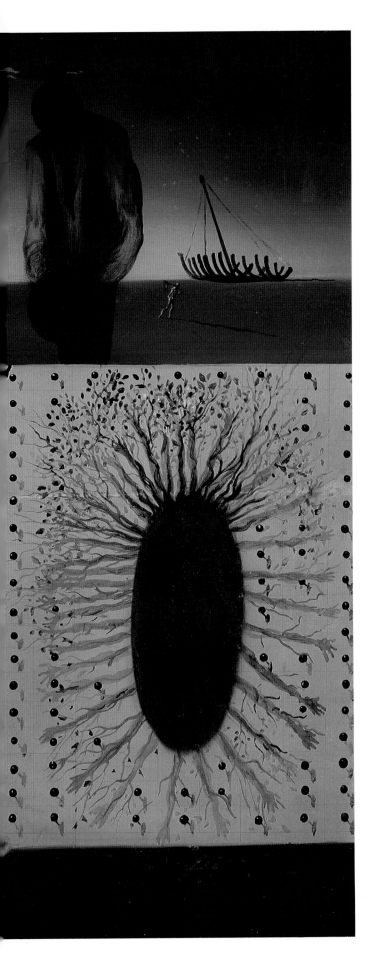

A WORLD OF WORK

All this was part of the New World spirit of the time and made Dalí a marketable commodity outside the arena of dealers and art galleries. He had already been designing for Elsa Schiaparelli and now began to turn out ever more fantastic items of fashion, which made the pages of *Vogue* and *Harper's Bazaar* and won him an increasing public among the rich and sophisticated. The Marqués de Cuevas, founder of the Monte Carlo Ballet, also brought Dalí into his world by commissioning him to design the decor for *Bachannale*, with costumes by Coco Chanel. Other ballet design commissions given to Dalí by the Marqués de Cuevas were *Labyrinth* (1941), which was choreographed by Léonide Massine, *Sentimental Colloquy*, *El Cafe de Chinitas*, and *The Broken Bridge* in 1944.

While in New York, Dalí and Gala made their home at the St. Regis Hotel, where he created a studio for working on the portraits of the rich and famous, among them Mrs. George Tait II, Helena Rubinstein, the cosmetics queen whose apartment Dalí also designed, Mrs. Luther Greene, Colonel Jack Warner and his wife, and such supporters and patrons as the Marqués de Cuevas and E. and A. Reynolds Morse.

Dalí also became involved once more in films, a medium which he greeted with enthusiasm as the creative kingdom of the future, though he was later to disparage cinema's contribution to art. Appropriately, he designed the famous surrealistic dream sequences in Alfred Hitchcock's 1945 film *Spellbound*; Hitchcock wanted it to be the first movie on psychoanalysis at a time when Freud's writings were beginning to have a profound effect on American thinking, so Dalí was an inspired choice. In the following year, Dalí worked on a project for Walt Disney, *Destino*, which was unfortunately never realized. There was to be only one more full-length film with a design by Dalí, the Spanish-made *Don Juan Tenorio* (1951).

As usual, Dalí enjoyed the frenetic activity and, with Gala constantly at his side, soon became known all over the United States as the king of modern art. Somehow or other, he even found time to write a novel, *Hidden Faces*, about a group of aristocrats on the eve of World War Two.

Tristan Insane

c. 1938, oil on panel; 18 x 21½ in. (46 x 55 cm).
Salvador Dalí Museum, St. Petersburg, Florida.
Before the outbreak of World War II Dalí had started work on his own interpretation of the Tristan and Isolde legend. This is one of the imaginative stage sets he painted on panels made for him by a carpenter from Figueras. The carpenter was killed by Franco's troops during the Civil War, one of several friends Dalí lost during the conflict.

ANXIETY AND TEMPTATION

Meanwhile Dalí's paintings were selling for large sums of money. Much of their appeal lay in the fact that they looked like Old Masters' works and were well crafted; almost as important, they were painted by a man who, however eccentric in some of his public behavior, was charming, civilized, well dressed, and quite evidently not a revolutionary or a Communist.

A significant Salvador Dalí painting of the 1940s was *Slave Market with the Disappearing Bust of Voltaire*, full of echoes of past work in Europe. The composition appears as a kind of stage set, with a half-nude Gala in

the left background looking across at a group of characters posed against a ruined building. Among these are two women in Dutch costume who, in an effective double-vision tour de force, appear also as the French sculptor Houdon's bust of Voltaire. Behind them, though low key, are the slaves to which the painting's title refers; they represent Dalí's state of mind, mingled with a Voltairian self-doubt, before Gala's influence gave him freedom and self-confidence.

Another painting which reveals the fact that Dalí was not entirely at ease away from his familiar landscape on the Costa Brava is *Dream Caused by the Flight*

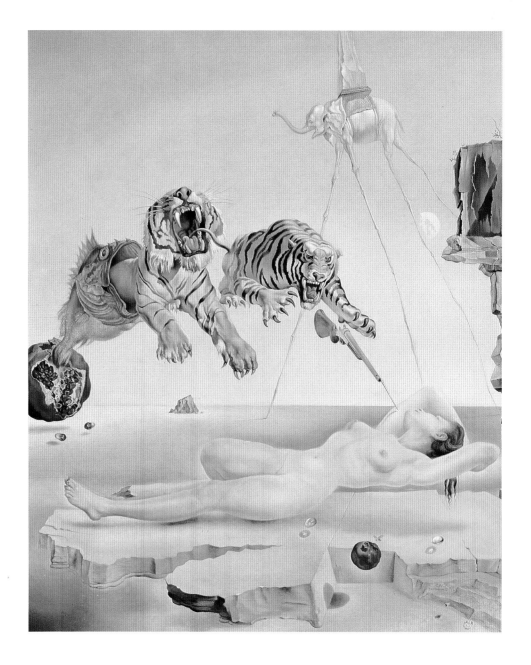

Dream Caused by the Flight of a Bee around a Pomegranate, One Second before Awakening

1944, oil on canvas; 20 x 15⅞ in. (51 x 40.5 cm). Coleccion Thyssen-Bornemisza, Madrid.

Dalí's involvement with so much commercial work in the United States did little for his imagination and affected the quality of his painting, which sometimes began to look like advertising graphics. Dalí himself referred to his work at the time as hand-made photography.

of a Bee around a Pomegranate, One Second before Awakening, painted in 1944. In this work Dalí portrays Gala on a stone slab, reviving echoes of the Cadaqués painting of his sister Ana Maria. Of the two tigers leaping over Gala, one is being eaten by a fish, a familiar Dalí nightmare. The whole painting seems a bit bland, like a piece of advertising graphic art, though this may have been the artist's intention for he said that it was "hand-done color photography."

The painting suggests that Dalí had temporarily lost contact with the subconscious stratum of his inspiration. This returned soon enough, however, when he took part in a competition run by the Loew Lewin Studios for a painting to be used in a film of *Bel Ami*, the novel by Guy de Maupassant. The subject was to be the Temptation of St. Anthony and although the competition was won by Max Ernst, the idea proved useful for Dalí, for it brought to him a new and fruitful painting series.

In Dalí's *The Temptation of St. Anthony* (1946) the saint is seen in the bottom left-hand corner of the painting, while sailing above him are a string of elephants led by a horse, their long, trailing, stiltlike legs giving them the appearance of tethered balloons. On

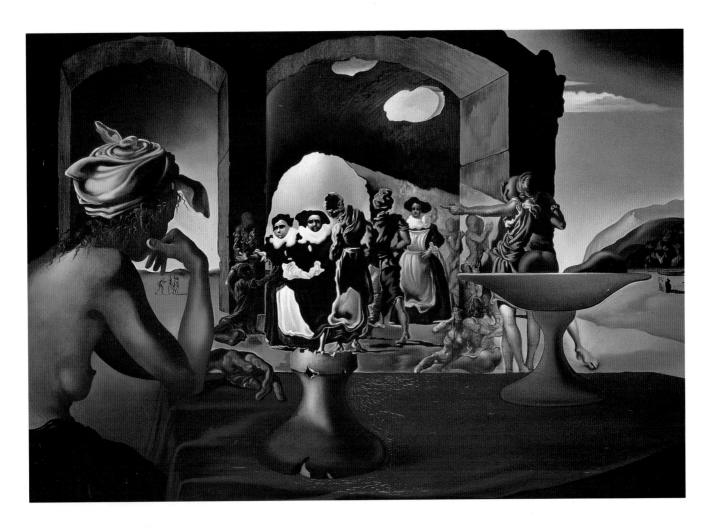

Slave Market with the Disappearing Bust of Voltaire

1940, oil on canvas; 18¹/₈ x 25¹/₂ in. (46.5 x 65.5 cm). Salvador Dalí Museum, St. Petersburg, Florida.
This is one of Dalí's most ingenious *trompe l'oeil* paintings in which he has so reinterpreted the Houdon bust of Voltaire that it is also two Dutch women in traditional costume. Voltaire stood for the quality of reason which Dalí regarded as the slave master of free fancy from the subconscious. On the left of the picture is Gala, who freed him from conventional thinking.

their backs the elephants carry temples with naked bodies. The inference is that temptations lie between earth and heaven; the meaning by now is not too abstruse as in Dalí's view sex was akin to mysticism. A further clue is in the discreet appearance on a cloud of Spain's El Escorial, a building which was for Dalí a symbol of the law and order that could be achieved by a fusion of the spiritual and the secular. *The Temptation of St. Anthony* is, then, a key picture in the Dalí cosmos, for it confirms his growing obsession with the world of the spirit and the world of matter, a duality which had its origins in the Dalí family setting of provincial Figueras.

THE ABSOLUTE VISION

This new vision of the world, Dalí claimed, was a

flash of enlightenment produced as a result of the flash and thunder of the atom bomb, exploded over Hiroshima, Japan, on August 6, 1945. Out of the dark clouds surrounding the explosion Dalí looked for a mystical answer. The Absolute Vision of what it all meant would arrive, he thought, by the Grace of Truth and by the Grace of God. The idea of the Grace of God had been within him since his youthful religious upbringing; the other, the Grace of Truth, would have to be found, the artist believed, within the discoveries of the modern science of physics.

Although Dalí's ideas about life, God, and modern science began to take shape in his mind in the United States and began appearing in his work there, they came to fruition only after his return in 1948 to his homeland at Cadequés.

Disappearing Bust of Voltaire

1941, oil on canvas; 18 x 21½ in. (46.3 x 55.4 cm). Salvador Dalí Museum, St. Petersburg, Florida.
This version of the *Bust of Voltaire* theme, for which Dalí did preliminary studies in gouache, omits the slave market. Here, the figures are shown in the arch of the wall while a decorative figure reaches up in the wall space.

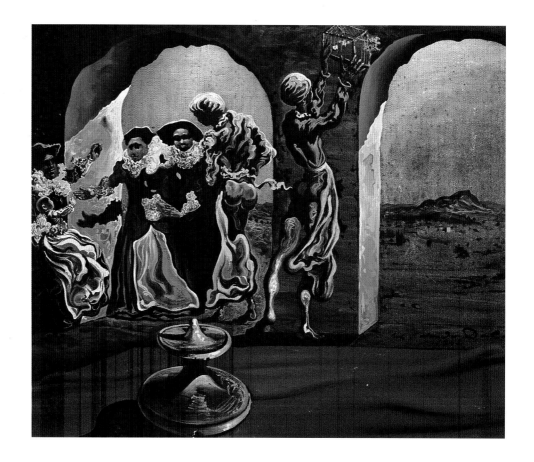

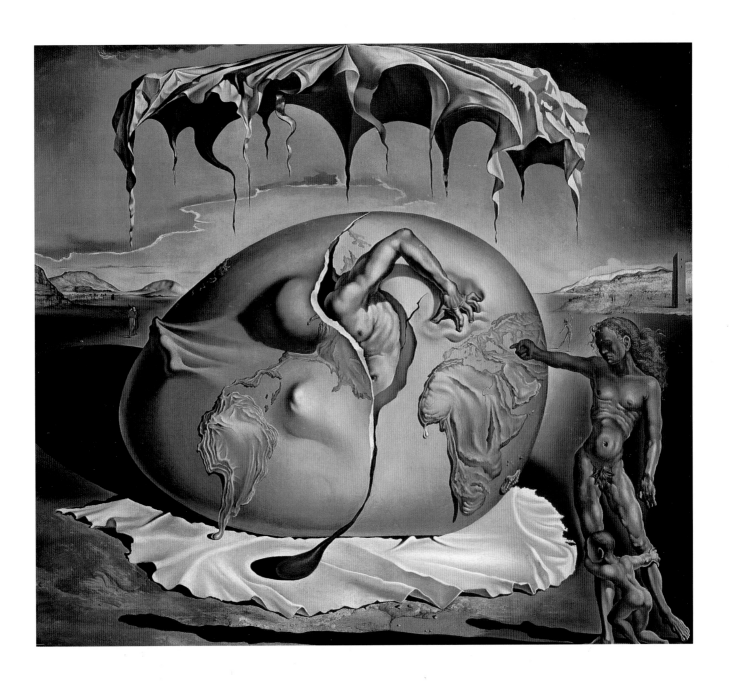

Geopolitical Child Watching the Birth of the New Man

1943, oil on canvas; 17¾ x 23 in. (45.5 x 59 cm). Salvador Dalí Museum, St. Petersburg, Florida.
The optimism of the New World inspired Dalí to break away from his European
introspection and to evolve a new mythology of a future world improved by liberal
philosophies and by the technology of a new civilization in which a new man would rule.

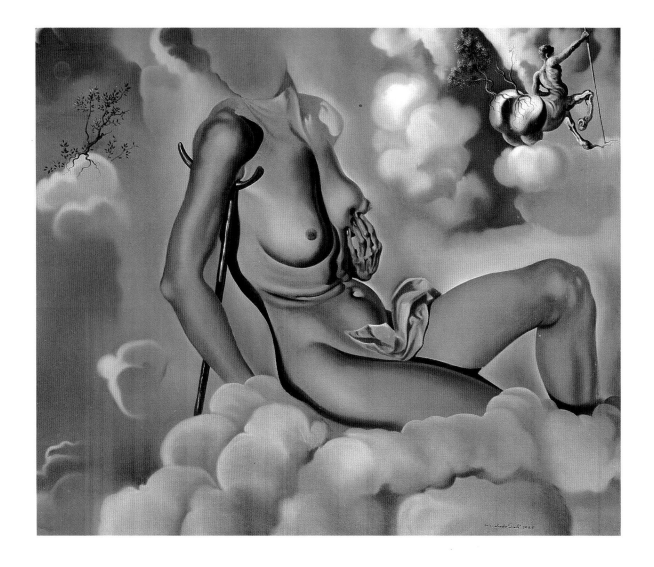

Honey is Sweeter than Blood

1941, oil on canvas; 19¼ x 23½ in. (49.5 x 60 cm). Santa Barbara Museum of Art, Santa Barbara, California.
Embarking on Surrealism in 1927, Dalí painted a canvas incorporating
some of the icons of his fears and obsessions. In this rather blander version,
a naked woman pressing her left nipple and a centaur in the sky
evoke a placid classical mood.

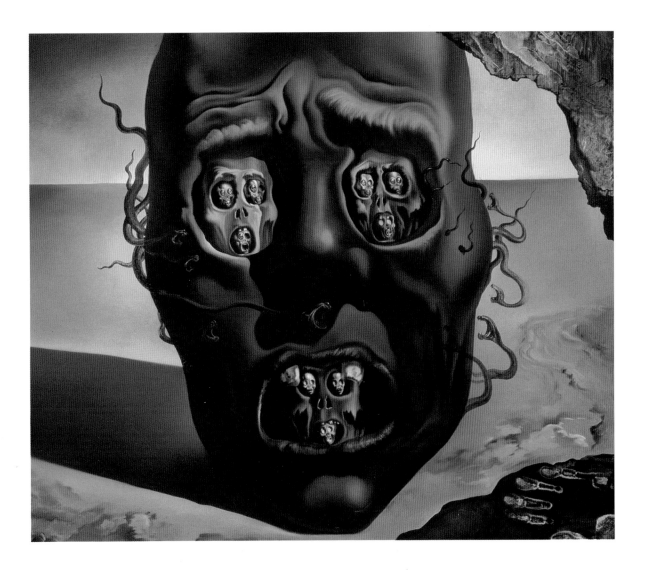

The Face of War

1940–41, oil on canvas; 25 x 30¾ in. (64 x 79 cm). Boymans-van Beuningen Museum, Rotterdam.
This "horrors of war" painting is a rather more conventional image than the ones
Dalí produced when civil war was raging in Spain, but it has some impact. The
skull, with its eyes and mouth filled with other skulls, has a certain Goya-esque fan-
tasy, reminiscent of the Spanish painter's etchings made during the Peninsular War.

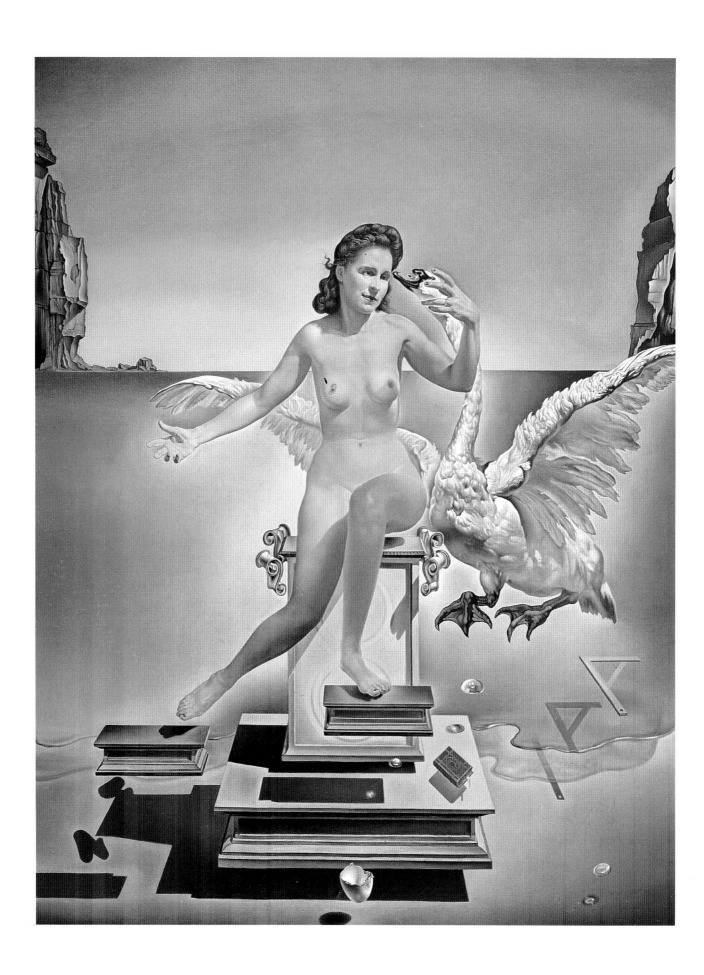

Dalí, God, and Physics

The shock of the nuclear bomb drove Dalí to produce his first atomic painting, *Three Sphinxes of Bikini*, in 1947. The "sphinxes" are three mushroom shapes, derived from the mushroom-shaped clouds that result from these massive explosions. The first, in the foreground, bursts like hair out of a woman's neck; the second, in the middle distance, appears as tree foliage; and the third is a distant cloud emerging from the landscape of Cadaqués.

THE MIND OF A MYSTIC

This was the first of a series of paintings and drawings addressing the destructive postwar world which Dalí now observed with unease and which led him toward a mystical approach to his work. It was an aspect of the new Dalí which had surfaced in his *Temptation of St. Anthony*.

Dalí chose to remain in the United States after the war ended in 1945, preparing for his own artistic renaissance. He was convinced now more than ever that the Renaissance artists were correct in painting religious themes and to do so in the way that they did. He declared war on the academic style of painting favored by traditional salons; on African art, which had so in-

Leda Atomica

1949, oil on canvas; 23¾ x 17½ in. (61.1 x 45.3 cm).

Fundacion Gala-Salvador Dalí, Figueras.

The appalling destructive power of the atomic bomb, as demonstrated in Japan in 1945, affected Dalí profoundly, both in a religious and in a scientific manner. The artist turned away from self-examination and introspection towards mysticism and nuclear physics. He now saw all matter as atomic particles and began to paint accordingly, as in this nude study of Gala. An earlier version of this painting, done in 1948, was left unfinished.

fluenced many of the important figures in European art, including Modigliani, Picasso, and Matisse; and on the decorative plagiarism of artists who became abstract painters because they actually had nothing to say. Dalí claimed that he was going to revive Spanish mysticism and demonstrate the unity of the universe by portraying the spirituality of matter.

One of the first paintings to carry his new vision was *Dematerialization Near the Nose of Nero* (1947). This work shows a fragmented cube, and an arch above it, in the curve of which floated a bust of Nero; the fragmentation was symbolic of atomic fission, a device that Dalí was to use over and over again.

Soon after his return to Spain, Dalí began work on two commissions, one for Peter Brook, the English theatrical producer, for his production of Richard Strauss' *Salome*, and the other for Luchino Visconti, the Italian film director, for a new version of Shakespeare's *As You Like It*. He also began working on studies for his *Madonna of Port Lligat* (1949), a painting of Gala as the Madonna. Finished before this important work, however, was Gala as *Leda Atomica* (1949), for which Dalí had been doing studies since 1947 plus an unfinished painting in 1948.

In *Leda Atomica* Gala floats nude on a pedestal with the swan's wings outspread behind her. Below and around the pedestal are a number of objects all floating weightlessly in space; in the background are the cliffs of Cadaqués. The myth of Leda was important to Dalí because he identified his relationship with Gala as the mating of Zeus and Leda, which had resulted in the swan producing two eggs from which had come two sets of twins: Helen and Polydeuces and Castor and Clytemnestra. In Dalí's eyes, he and Gala were twins sharing a joint life and joint memory and one could not exist without the other.

The *Madonna* painting is similar in composition: Gala is dressed as a conventional Renaissance

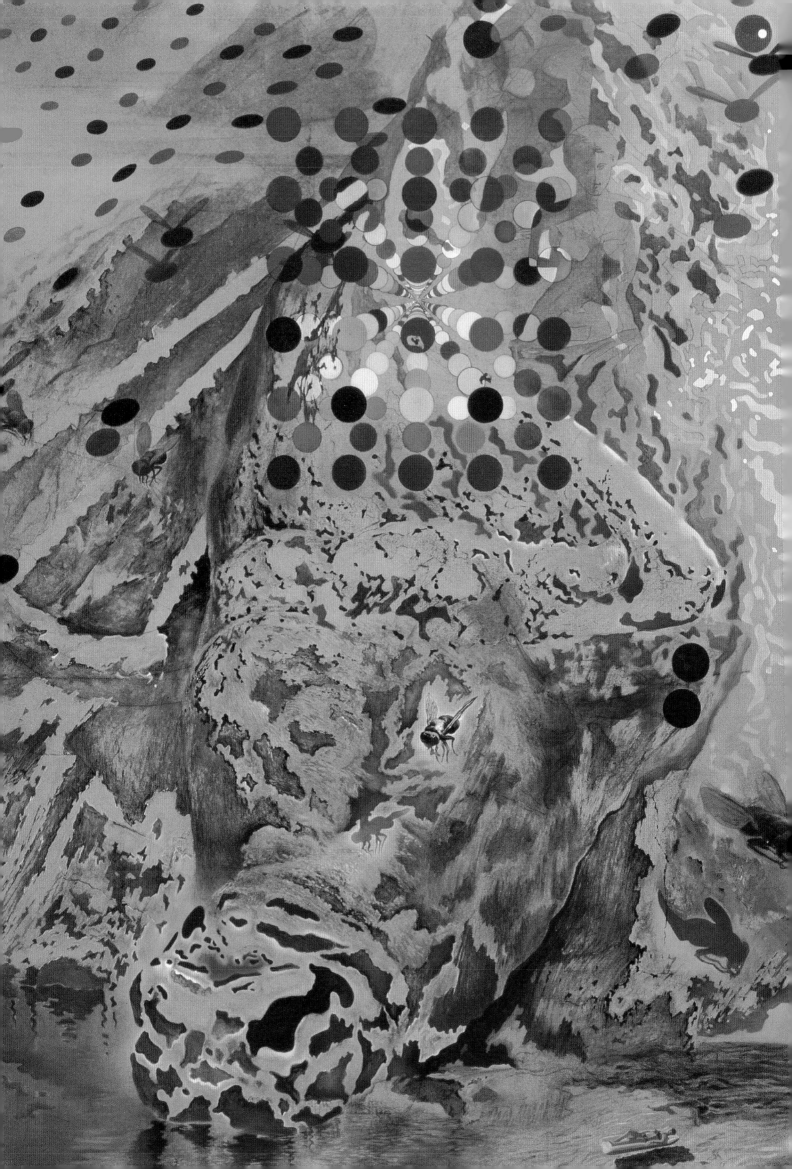

The Madonna of Port Lligat

1949, oil on canvas; 19 x 14½ in. (48.9 x 37.5 cm). Marquette University, Haggerty Museum of Art, Milwaukee, Wisconsin.

The style of this painting is derived from the art of Piero della Francesca, whose clear and lucid technique, like that of Botticelli, became typical of Dalí's work. The pose of the female figure is similar to that of *Leda Atomica*, but here Gala appears clothed and set within an archway in atomic fragmentation.

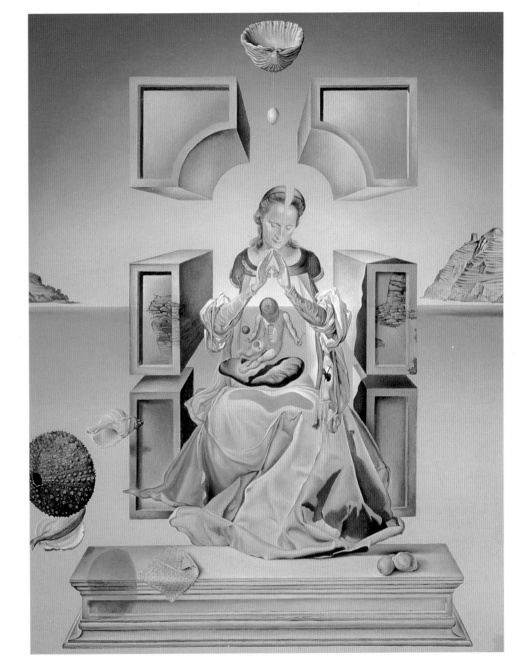

The Hallucinogenic Toreador

detail; 1968–70. Salvador Dalí Museum, St. Petersburg, Florida.

The subtlety of Dalí's double vision technique is well seen in this detail, where a dying bull is also part of the matador's cape and the bull's eye is a bluebottle which is repeated to give the illusion of the sequins on the matador's costume. The flies, sequins, and dots give an overall suggestion of flying particles, in keeping with Dalí's ideas on physics and the nature of matter.

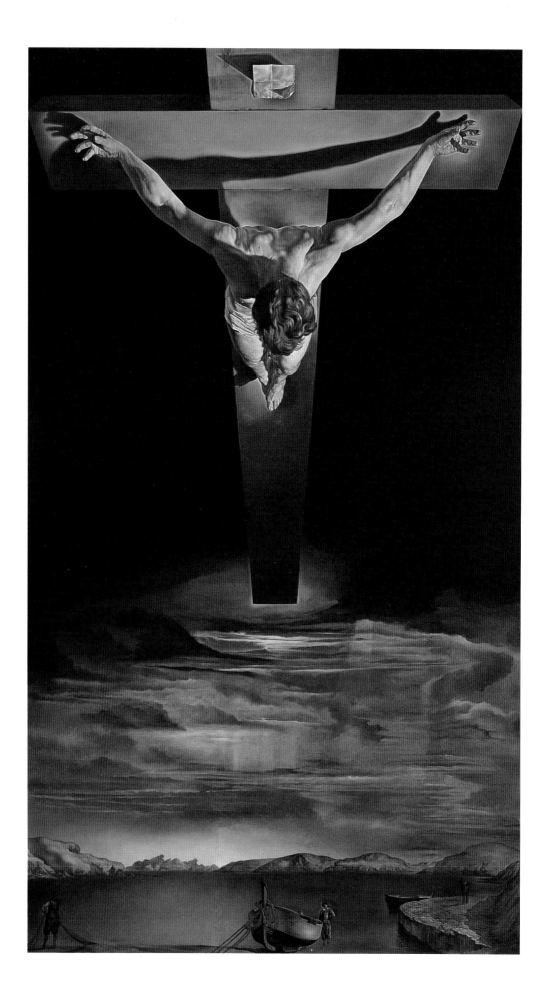

**Christ of St. John
of the Cross**

*1951, oil on canvas;
80 x 45¼ in. (205 x 116 cm).
Glasgow Art Gallery, Glasgow.*
Dalí liked to amaze every-
one by the quality of his
technique. This crucifixion
shows him at his most
brilliant, showing off an
exaggerated perspective
and a particularly fine fin-
ish of the Christ who hangs
over the bay at his and
Gala's home at Port Lligat.

Madonna with the central panel of her dress opened up to reveal the Christ Child floating above a blue cloud or cushion. The Madonna sits in a broken arch; over her head floats an egg and above that a scallop shell, a symbol of St. James, who landed on Spanish shores on a shell in the same way as Aphrodite landed in Cyprus. Other objects floating around the Madonna include shells and fish; once again the Cadaqués shore makes up the background. The painting is straightforward, without paranoiac-critical, double-vision, *trompe l'oeil* effects, and expresses Dalí's declared intention to continue working within the classical framework which for him was the highest point of artistic development and from which all new art should come.

That Dalí by now had moved a long way from his socially and politically radical views of the 1930s was emphasized by the fact that he had an audience with the Pope, Pius XII, in November of 1949, during which he sought his blessing for the first version of his *Madonna of Port Lligat*. It can be assumed that the Pope did not know that Gala, the model for the Madonna, was a very promiscuous woman or that Dalí himself considered her to be divine.

Dalí painted a second version of *The Madonna of Port Lligat* in 1950, using the same composition as the first but adding many more items relevant to Dalí and Gala, including the rhinoceros which would appear in his *Lacemaker* and rhinoceros series.

THE PERSISTENCE OF DALÍ

At this time Dalí was also working on a number of other projects, among which were the scenery and costumes for a production of Manuel de Falla's ballet *El Sombrero de Tres Picos* ("The Three-Cornered Hat"). In the design Dalí introduced flour sacks and trees floating in space, while the miller's house itself was seen to be disintegrating with its doors and windows askew, one of them flying off into the sky.

Dalí also found time to do many portraits, including one in 1949 of art collector Sir James Dunn. Fine theatrical portraits done in the 1950s included Katherine Cornell (1951) and Laurence Olivier in the role of Richard III (1955). Portrait painting, a big money earner, remained high on Dalí's list of priorities into the 1970s. His 1974 equestrian portrait of Francisco Franco's daughter, Carmen Bordiu-Franco, was presented to Spain's leader in a special ceremony.

Dalí's most important painting of 1951 was *Christ of St. John of the Cross*, a crucifixion hanging in the sky above Port Lligat. This impeccable and unprovocative

work, free of Surrealistic overtones, was sold to the Glasgow Art Gallery, where it was slashed soon after it was hung by a vandal protesting the sum of £8,200 which the gallery had spent in acquiring it. (Within five years the gallery had got its money back, with interest, in entry fees and the sale of reproduction rights.) A companion piece with the same visually simple approach is *Eucharistic Still Life*, a painting of a table covered with a cloth on which lie bread and fishes. Both these paintings display a simplicity un-

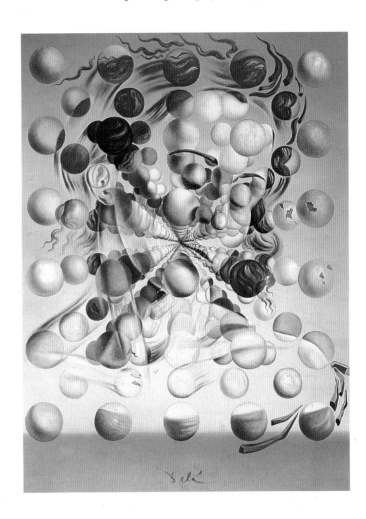

Galatea of the Spheres

1952, oil on canvas; 25¼ x 21 in. (65 x 54 cm). Fundacion Gala-Salvador Dalí, Figueras.
The exploding bust of Gala in this painting reveals Dalí's preoccupation with the new ideas of physics, in which solid matter is seen to be charged particles whirling in space. Dalí's penchant for *trompe l'oeil* and double vision is given full reign in this ingenious creation of a Gala made up of spheres around a central perspective diving into the back of the painting.

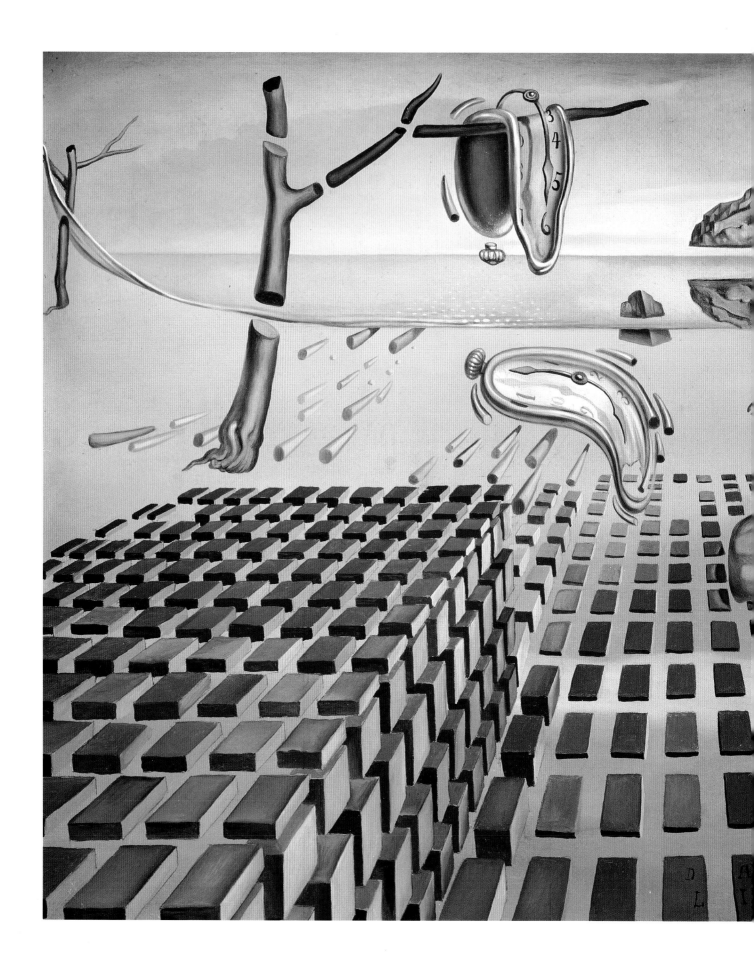

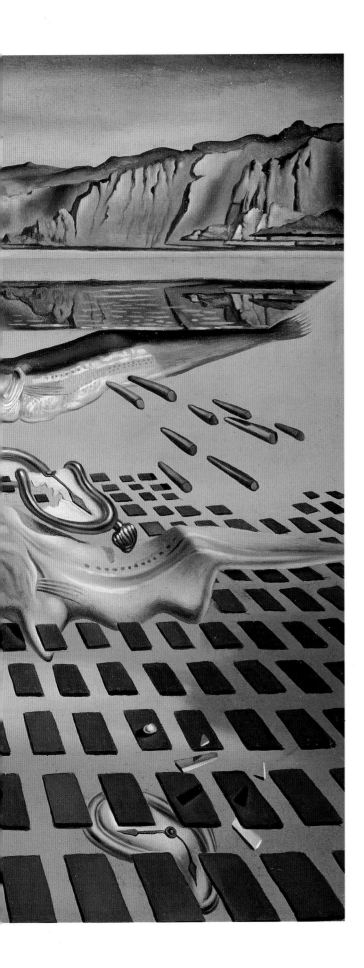

usual for Dalí, perhaps reflecting his pleasure and thankfulness at finding himself once more on his home territory at Port Lligat.

Dalí's main preoccupation now, though, was the development of his thoughts on mysticism and science. He produced a number of drawings of a disintegrated Raphaelesque head, the interior of which was the inside of the Pantheon in Rome. His continuing exploration of this new line in disintegrating or explosive paintings culminated in *Galatea of the Spheres* (1952), in which Gala's head is made up of rotating spheres. He also painted himself nude on the beach kneeling next to a disintegrated head of Gala, which he entitled *Dalí Nude, in Contemplation before the Five Regular Bodies Metamorphized into Corpuscles, in which Suddenly Appear the Leda of Leonardo Chromosomatized by the Visage of Gala* (1954).

His preoccupation with new ideas on relativity caused him to turn back to the *Persistence of Memory* of 1931. Now, in *The Disintegration of the Persistence of Memory* (1952–54), Dalí showed his soft watches in an undersea setting with brick-shaped rocks stretching away in perspective. Memory itself was in a process of disintegration, since time no longer existed in the sense that he had originally thought.

The serious Dalí who was producing religious and scientific paintings needed, as he always had, the relaxation of painting erotic and black-humor works. Teaming up with his photographer friend Philippe Halsman, Dalí produced in 1954 a book called *Dalí's Mustache: A Photographic Interview*. "Me crazy? I am certainly saner than the person who bought this book," was a typical remark from Dalí when the book—celebrating the famous extravagantly waxed mustache that Dalí called his "antennae to the arts"—was launched.

In that year he also painted *Young Virgin Auto-Sodomized by her Own Chastity*, a picture of a nude woman seen from behind, threatened by several rhinoceros horns. The rhinoceros horn was a new Dalí

The Disintegration of the Persistence of Memory

1952–54, oil on canvas; 9³⁄4 x 12⁷⁄8 in. (25 x 33 cm).
Salvador Dalí Museum, St. Petersburg, Florida.
While in the United States, Dalí had come to feel that Americans were tyrannized by time, and his famous soft watches were taken up again as a theme of the painting he created when he returned to Spain after his sojourn in the United States. The setting here is still the shore of Cadaqués, but its bed is now disintegrating as Dalí incorporates his version of a world made up of particles into his work.

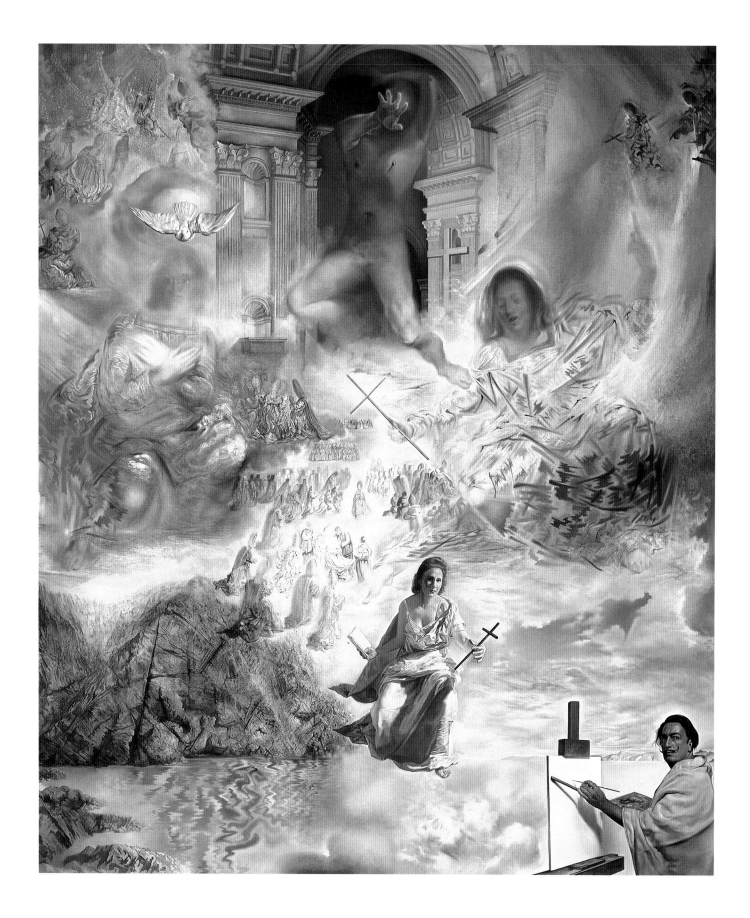

icon. He linked it to Jan Vermeer's *Lacemaker* in several works in 1955 and the idea was exploited in a film, *L'Histoire prodigieuse de la Dentellière et du Rhinoceros*, directed by Robert Descharnes, in which Dalí repainted Vermeer's picture in the rhinoceros enclosure at the Vincennes Zoo in Paris. With this incongruous juxtaposition of a lacemaker and a rhinoceros Dalí was back within his paranoiac-critical world and made capital out of it by appearing for a lecture he gave at the Sorbonne on "the phenomenological aspects of the paranoiac-critical method" in a limousine ("limousine" was Dalí's name for a penis) covered with cauliflowers.

But Dalí had not given up on his resurfacing religious inclination. This reappeared in 1955 in *The Sacrament of the Last Supper*, a work in which robed figures kneel around a table in a room overlooking Port Lligat bay, from whose waters an almost transparent Christ is emerging. It also was apparent in *The Ecumenical Council* (1960), a painting in which Dalí included himself. In the left-hand corner Gala holds a cross; behind her is a misty scene full of figures above which flies the white dove of the Holy Ghost.

The prolific artist's work at this time showed many variations in style and approach, as if he had not yet

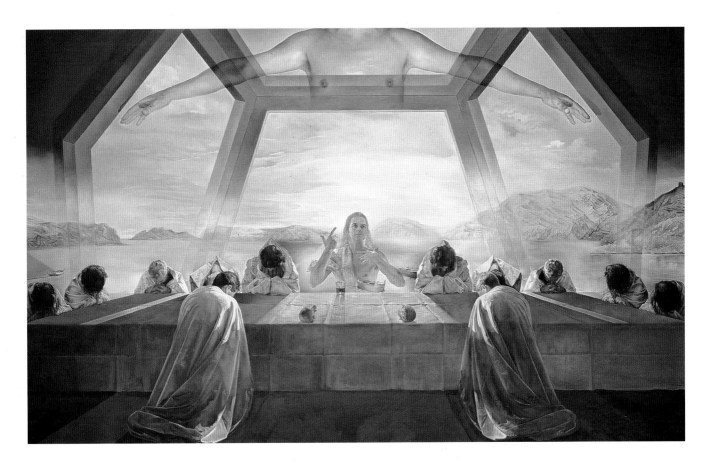

The Ecumenical Council

1960, oil on canvas; 117 x 99 in. (300 x 254 cm).

Salvador Dalí Museum, St. Petersburg, Florida.

This *tour de force* has the background grandeur of a Roman church, heightened by the Michelangelo-esque appearance of the figure leaping out of the architecture. Gala as a madonna figure is in sharp focus, in the foreground, in front of the artist. While he was producing such distinguished work, Dalí was also experimenting, with Max Ernst, on pictures made of blunderbuss shots.

The Sacrament of the Last Supper

1955, oil on canvas; 65⅛ x 104½ in. (167 x 268 cm).

Chester Dale Collection, The National Gallery of Art, Washington, D.C.

Without the setting, which evokes a science-fiction spaceship atmosphere, this painting could almost be a straightforward depiction of the Last Supper painted in Dalí's impeccable realistic style, though the figure floating outside adds a Surrealist touch. The scenery is the Cadaqués coast.

found the new way in art that mysticism and science had seemed to point out. The perfection of his technique remained unchanged, as is well shown in paintings like *The Discovery of America by Christopher Columbus* (1958), a tour de force in which Columbus' ship and Gala appear together in a complex, blue-gray composition, and *The Virgin of Guadalupe* (1959), a pyramidal composition with the Virgin and Child at the apex of a splendid robe rising from clouds on which kneel two priests. Dalí was also looking for new approaches to the techniques of painting, however, even experimenting with a specially constructed arquebus to fire nails and bits of metal at a drawing.

PAINTING HISTORY AND PICTURING TRAINS

While pursuing his new ideas with the usual ferocious energy, Dalí designed more ballets, including *The Grape Pickers* in 1953 and a *Ballet for Gala*, for which he did the libretto and sets and Maurice Béjart the choreography. The latter was first performed in 1961 at the Fenice Theater in Venice. He also continued to make public appearances, including one in Rome where he appeared in a "Metaphysical Cube" (simply a white box decorated with scientific symbols). There is no doubt that many of the people who turned up at the Dalí spectacles were simply curious about the eccentric celebrity; his true supporters were not happy with them, feeling that the showman was obscuring the work of the artist.

To these, Dalí would reply that he was not a clown but that, in its naiveté, a monstrously cynical society was not aware that it was putting on a serious act to hide its own madness. Attacking modern art for having led the public up a blind alley, Dalí spoke up in favor of such once admired but now unpopular artists as French historical genre painter Jean-Louis-Ernest Meissonier and Mariano Fortuny, who had painted great and noble epic scenes for establishment buildings.

These artists, dismissed as *pompiers* ("firemen") by admirers of modern art, were good realistic painters, declared Dalí, and he showed that he could equal them with his large painting *The Battle of Tetuán* (1962), which was eventually placed alongside a Fortuny

painting at the Palacio del Tinell in Barcelona. Dalí's picture was much in the style of a Eugène Delacroix battle scene, well drawn and with plenty of action—and, naturally, with Gala standing in the background.

After one of his regular visits to the United States, where his fame spanned the continent and the sale of his paintings was prodigious, Dalí returned to Europe in 1962 with another scientific development for use in his painting. This was the electrocular monocle, a device which allowed an image to be transferred televisually to a telescopic tube and allowed the eye to see the image and everything around it simultaneously. This, explained Dalí, was the answer to his double-vision and paranoiac-critical method because it would help expand his vision in the same way that others used drugs to expand theirs.

For whatever reason, Dalí's paranoiac-critical method now re-emerged forcibly in *The Railway Station at Perpignan* (1965). Perpignan is the first large town encountered in France after leaving Catalan Spain, and therefore had a special symbolic significance for the painter as the entry and exit point to and from the rest of the world. It was here, too, he once remarked, that "when Gala is making arrangements for the paintings to follow us by train, I have my most unique ideas."

In Dalí's depiction of this important place, the railway station is an undefined area of space; a train hovers above a void in which a figure, Dalí himself, is falling or floating weightlessly with outstretched arms before a ghostly male figure. At each side are the man and woman from Millet's *Angelus* and behind each one another couple resides, close together in a sexual context.

**The Discovery of America
by Christopher Columbus**
detail; 1958–59. Salvador Dalí Museum, St. Petersburg, Florida.
Dalí's reference to Velázquez's *The Surrender of Breda* cleverly uses the pikes which were a feature of Velázquez's painting both as a reminder of Spanish glory and, technically, as a screen in the sky, to create a deeper space and a feeling of distance.

A REVIVAL OF REPRESENTATIONAL ART

The *Railway Station* painting, whose meaning was important to Dalí as it brought together the *Angelus* symbolism of his life with Gala and his profound attachment to his part of Catalonia, proved to be a spur to his creativity, out of which came the ambitious *Tuna Fishing* (1966–67), which Dalí subtitled "Homage to Meissonier."

The subject of *Tuna Fishing* was a simple one—fishermen catching tuna. But Dalí used the painting to break new ground in technique, deserting his smooth Renaissance style and mingling Pointillist, Fauvist, and other techniques with a total, almost anarchic freedom of brushwork. The scene shows groups of fishermen surrounding shoals of tuna which are being dispatched with knives, swords, harpoons, and other implements, all of which express the violent action of the hunt. This moment in time, said the artist, was the meeting place of the finite world. Dalí dedicated the painting to Meissonier because, he claimed, it was a revival of representational art.

Following this work, which took him nearly two years to complete, Dalí launched himself into another great work, *The Hallucinogenic Toreador* (1968–70). Here once more was a revival of the paranoiac-critical, double-vision technique but in a new and polished manner. It called up many of the now traditional Dalí icons, including the Venus de Milo, Gala, the rocks of Cadaqués, and Dalí as a young boy in a sailor suit (as he had depicted himself in *The Specter of Sex Appeal* in 1932). The hidden figure behind the Venus de Milo is Manolete, Spain's legendary bull fighter, but he is also Salvador's dead brother, the poet Lorca, and a host of friends who had remained in Dalí's memory, awakening Dalí's own fear of death and extinction.

While immersed in these large works, Dalí's creative energy led him to produce many others, including prints, erotic drawings, a series of Dalí horses, and more drawings of Gala, who was still the center of his universe, as evidenced in *Dalí from the Back Eternalized by Six Virtual Corneas Provisonally Reflected in Six Real*

The Hallucinogenic Toreador

1968–70, oil on canvas; 155½ x 116¾ in. (398.8 x 299.7 cm).
Salvador Dalí Museum, St. Petersburg, Florida.

Although, unlike Picasso, Dalí was not inspired by the bullfight, he used a toreador in this fine painting, which has an underlying death theme. The matador could be Dalí's dead brother or perhaps the famous bullfighter, Manolete, who was killed by a bull. The Venus de Milo and pieces of Roman architecture in the picture are reminders of a dead past.

Mirrors (1972–73), a celebration of their partnership which, by now, had endured for more than forty years. It is an impeccably painted double portrait that lives up to Dalí's claims for the perfection of the techniques of the Renaissance.

TEATRO MUSEO DALÍ

From about 1970, Dalí's health began to decline. Though his energy was undiminished, thoughts of death and immortality began to preoccupy him. He was convinced that immortality was possible, including the immortality of the body, and investigated the preservation of the body by freezing and the transference of his DNA so that it could be reborn. More important, however, was the preservation of his work, and this became a tangible project to which he now set his mind.

Dalí got the idea of building a museum for his work. Soon enough the artist set about transforming, in Figueras, his birthplace, a theater which had been badly damaged during the Spanish Civil War. Over the stage a giant geodesic dome was erected. The auditorium was cleared and divided into areas that could hold different aspects of the work, including the Mae West bedroom and large paintings like *The Hallucinogenic Toreador*.

Dalí painted the entrance foyer himself, depicting he and Gala showering gold on Figueras, their feet dangling from the ceiling. The salon is named the Palace of the Winds after the poem which recounts the legend of the East Wind, whose married love lies to the west so that always as he approaches her he is forced to turn, his tears falling on the earth below. This legend pleased Dalí, the great myth maker, who also dedicated another part of the museum to eroticism. As he liked to point out, eroticism was not the same as pornography, for the former made everyone happy while the latter brought misfortune.

Much other work and bric à brac was also included in the Teatro Museo Dalí, which opened in September of 1974, giving it the air of a fairground as well as a museum. In it there are examples of Dalí's experiments with holography, from which he had hoped to create a three-dimensional total vision. (His holograms were first exhibited at the Knoedler Gallery in New York in 1972; he abandoned his experiments in 1975.) Also in the Teatro Museo Dalí are double-image spectroscopic pictures showing Gala nude in a work that includes a background of a Claude Lorrain painting and many other objects created by Dalí.

The demand for Dalí's work had become endless, with book publishers, magazines, fashion houses, and

Dalí from the Back Painting Gala from the Back Eternalized by Six Virtual Corneas Provisionally Reflected in Six Real Mirrors

1972–73, oil on canvas; stereoscopework on two components; 23½ x 23½ in. (60 x 60 cm) each. Fundacion Gala-Salvador Dalí, Figueras. Despite its whimsical title, this work shows Dalí at his realistic best. Here, he acknowledges his admiration for the Dutch painter Vermeer, whose *The Lacemaker* was teamed up by Dalí with a rhinoceros for a series of paintings with Freudian implications.

theatrical producers vying for his contributions. He had already illustrated many of the great works of world literature, from the Bible to Dante's *Divine Comedy*, as well as Milton's *Paradise Lost*, Freud's *God and Monotheism*, and Ovid's *Art of Love*. He was also producing Surrealist objects such as the *Funeral Mask of Napoleon Covering a Rhinoceros*, a *Hallucinogenic Toreador* with drums, scissors, and spoons, a soft watch surmounted by a crown, and *Le Vision de l'Ange with God's Thumb and Twelve Angels*.

The Dalí cult and the fact that he produced so much work and of such variety led to numerous imitators and the production of many fakes, which caused great problems in the international art market. Dalí himself became implicated in scandal in the 1960s when he signed many blank sheets intended for making prints from lithographic stones held by dealers in Paris. There were accusations that many of these blanks were used fraudulently. Dalí, however, was untroubled and continued his frenetic lifestyle into the 1970s, as ever searching for new plastic avenues to explore in his wonderful world of art.

THE END OF THE DREAM

Salvador Dalí lived two dreams, one that grew out of the ideas teeming in his own head and one that grew out of his youthful hope for a fulfilled life complete with essential comforts. The first, entirely his own, was one to which the world at large was granted an occasional glimpse without understanding fully the workings of the artist's mind; the second was fostered by Gala and their friends, who helped him to achieve the recognition which brought worldly success.

Dalí's own acknowledgment of the part that Gala played in his life was continuous from the moment they met and her influence, as model and muse, was important to most of his work. In the late 1960s, Dalí's gratitude took tangible form: he bought her a castle at Pubol, near Figueras, decorating it with his paintings and giving it every comfort and luxury. Whether Gala actually wanted the castle is not as understood; many people thought that she would have preferred to live in Tuscany. Whether Gala's castle home indicated that she and Dalí were living separate lives was also not clear. Their lives and the Gala-Dalí business partner-

ship were so inseparable after nearly forty years that a complete break would have been unthinkable.

Throughout her life with Dalí, Gala had played éminence grise, preferring to remain in the background, recognized by some as the power behind the Dalí image and viewed by others as a scheming witch. When English television personality Russell Harty interviewed Dalí in 1973 for a BBC television program Gala reluctantly agreed to appear, momentarily, in a doorway, but when Harty and his crew were about to join Dalí in his swimming pool she disappeared altogether. Perhaps by now she was tired of all the clowning and public shows.

Gala and Dalí had always managed their affairs and his increasing fortune with businesslike efficiency. It was she who insisted that Dalí should be paid for his public appearances and she kept a careful watch on his private deals for his paintings. She was essential to him physically and spiritually as well as for practical reasons, and when she died in June of 1982 he was bereft.

Driven by a desire to remain close to her spirit, Dalí moved to the castle at Pubol and his public appearances nearly ceased. Despite this, his reputation continued to grow. In 1982 the Salvador Dalí Museum, which had been set up in Cleveland, Ohio, to house the great body of his work collected by E. and A. Reynolds Morse, was moved to an impressive site in Saint Petersburg, Florida. The Centre Georges Pompidou in Paris had mounted a large Dalí retrospective in 1979, later sent across the Channel to the Tate Gallery in London; the retrospective's double showing brought Dalí's work to a very wide audience and made him in Europe an immensely popular artist.

Among the awards showered on Dalí was membership in the Académie des Beaux-Arts in France. Spain awarded him its highest honor, the Grand Cross of Isabella the Catholic, which was bestowed on him by King Juan Carlos in person. He was created Marquis de Pubol in 1982.

Though unwell and unhappy, Dalí buried himself in work, his lifelong admiration of the Italian Renaissance artists leading him to produce paintings and drawings inspired by Michelangelo's heads of Giuliano de Medici, Moses and Adam (in the Sistine Chapel), and by his Pieta in St. Peter's in Rome. He also began to draw in a freer manner. A linear, expressionistic style reminiscent of Vincent van Gogh emerged in paintings such as *Bed and Bedside Table Ferociously Attacking a Cello* (1983), in which the disciplined, classical lines of Dalí's earlier work were seen to be giving way to a looser, more romantic style.

Then, in 1984, a catastrophe virtually ended Dalí's life as an artist. He had been bedridden for some time

Bed and Bedside Table Ferociously Attacking a Cello

1983, oil on canvas; 50¾ x 54 ⅔ in. (130 x 140 cm). Fundacion Gala-Salvador Dalí, Figueras.

Dalí spent his last years at the castle at Pubol, which he had given Gala and where she lived until her death. The artist was ill and bedridden, and one day his room caught fire. Although he was saved by friends, he was badly burned. This painting expresses his frustration at becoming a prisoner of his ill health and advancing years.

and, somehow, his bed caught fire, perhaps because of a faulty bedside light. His whole room began to burn. He managed to crawl toward the door and was pulled to safety by Robert Descharnes, the administrator of his affairs now for many years.

Dalí was badly burned and from then on little was heard of him, although Descharnes published his mono-graph *Salvador Dalí: The Work, The Man* in 1984. Inevitably, rumors began to circulate that Dalí was entirely incapacitated, that he had Parkinson's disease, that he was being kept a prisoner against his will, even that for some years he had not been physically capable of doing all the works which kept appearing under his name.

"THE REAL DALÍ"

Salvador Dalí, Marquis of Pubol, died on January 23, 1989, six years after he completed his last painting *The Swallow's Tail*, a simple calligraphic composition on a white sheet. The simplicity of the work is reminiscent of the work of Paul Klee and is as touching as a melody on a violin.

Was this "the real Dalí"? Underneath the antennae mustache, which a French magazine writer had once begged him to cut off so that the true Dalí could be seen, was there a simple village philosopher with an instinctive wisdom? Many people think so and regret the aphrodisiac dinner jacket, pubic lobsters, sodomized pianos, and the system of *Caga y Menga* ("Shit and Eat") with which he constantly called for attention.

While working on his last painting Dalí told one of his rare visitors that he was going to paint a series based on catastrophes which would no longer be a matter of pure imagination, of his moods and dreams, but would come out of the reality of his illness and existence and vital memories. One cannot help but wonder if sometimes Salvador Dalí saw his own life as a sort of catastrophe. Blessed with a titanic energy and a fertile and creative mind, he had also been cursed with the natural talent of an entertainer, and had as a result obscured his reputation as an artist.

Like most artists, including such modern masters as Paul Cézanne and Claude Monet, Dalí probably felt that he never fulfilled the vision that had burned in his soul. But his undoubted mastery of the style which he evolved and the power of his most potent statements touched a chord in numerous people of widely diverse cultures. His most memorable images belong among the icons of the art world's spiritual pantheon and are likely to remain sturdy landmarks in the art of the twentieth century.

Appropriately, Salvador Dalí lies interred, as he wished, in the crypt of his Teatro Museo Dalí in Figueras. He left his fortune and his work to the Spanish state.

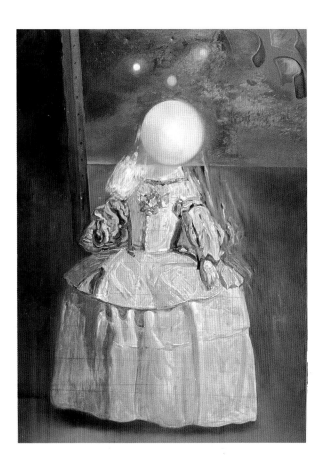

The Pearl

1981, oil on canvas; 54 ⅔ x 39 in. (140 x 100 cm).

Fundacion Gala-Salvador Dalí, Figueras.

Among his heroes of painting, Dalí ranked Velázquez the greatest. He was particularly impressed by *Las Meninhas*, which Velásquez had painted for Philip IV near the end of his life. Dalí produced his own version of one of the dwarfs in the Velázquez painting— perhaps inspired by another Velazquez masterpiece, *An Old Woman Frying Eggs*, Dalí covered his version of the little servant in fried eggs.

Pietà

1982–83, oil on canvas; 39 1/16 x 39 in. (100.2 x 100 cm). Fundacion Gala-Salvador Dalí, Figueras.

In the last years of his life Dalí turned more and more to the work of the great
Renaissance artists in his search for inspiration. The various carvings of the Pietà
by Michelangelo, with their powerful emotional impact, were a particular spur
for Dalí, leading him to create his own versions of the dead Christ and his mother.

115

**Velázquez Painting
the Infanta Margarita
with the Lights and
Shadows of His
Own Glory**

*1954, oil on canvas; 59½ x 35¾ in.
(153 x 92 cm). Salvador Dalí
Museum, St. Petersburg, Florida.*
Though his own paintings
were more in the style of
the early Renaissance
painters like Botticelli,
Dalí admired Velázquez.
In this painting, he pays
tribute to the Spanish
master in a work in which
the overpainted images are
evidence of Dalí's own skill.

The Discovery of America by Christopher Columbus

1958–59, oil on canvas; 160 x 110¾ in. (410 x 284 cm). Salvador Dalí Museum, St. Petersburg, Florida.
Barcelona has long preserved a replica of Columbus' ship the *Santa María* as a celebra-
tion of the mariner's arrival at the port on his return from the New World. Dalí's pride
in the role of Catalonia and in the introduction of Spanish religious culture into the
heathen continent inspired this painting, which shows Gala on the seafarer's banner and
a reference to the Velázquez painting, The Surrender of Breda, in the pikes at the right.

**Raphaelesque Head Breaking
(Exploding Raphaelesque Head)**

1951, oil on canvas; 17¹/₂ x 13³/₄ in. (44.5 x 34.9 cm). Private collection.
In a theme closely related to Renaissance painting, the head of a
Madonna (after Raphael) has been joined with the Pantheon—
then broken into fragments in the shape of rhinoceros horns.

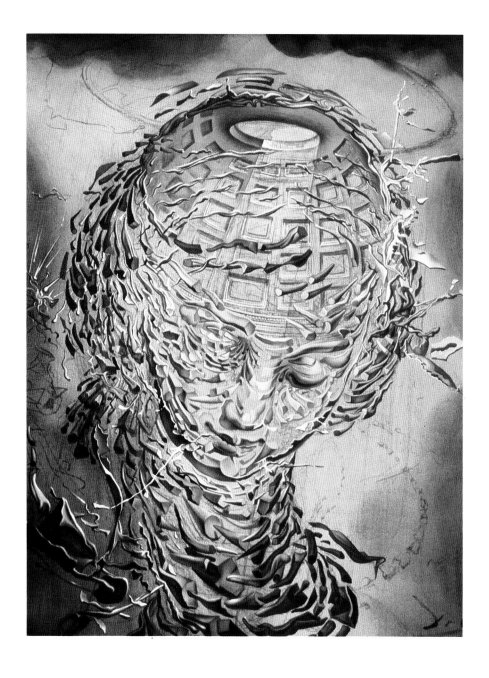

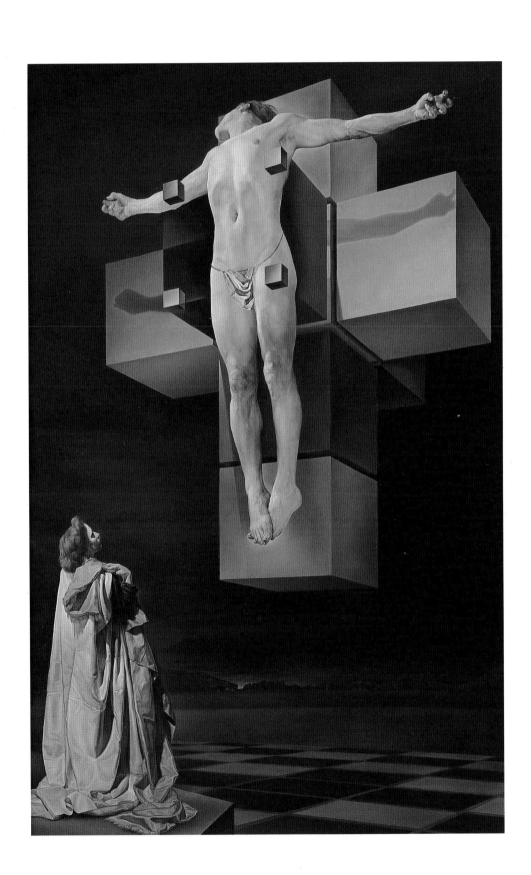

Corpus Hypercubus (Crucifixion)

1954, oil on canvas; 75³/4 x 48 ¹/3 in. (194.5 x 124 cm). Gift of Chester Dale, The Metropolitan Museum of Art, New York. In the course of his life Dalí became more and more impatient with modern art and more admiring of the work of the Old Masters. Here, however, he has made the cross out of cubes, though not Cubist, while the figures of Christ and Gala remain naturalistic.

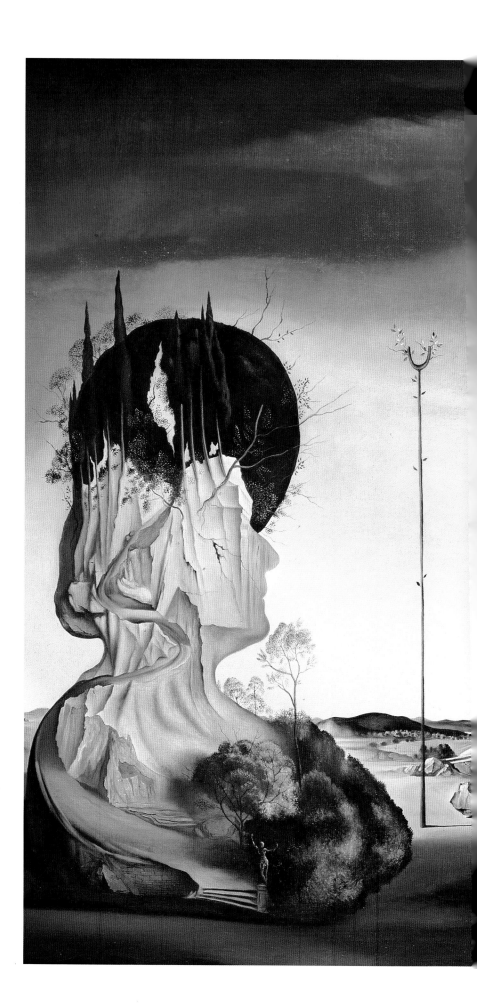

**Portrait of
Mrs. Isabel Styler-Tas**

*1945, oil on canvas; 25½ x 33½ in.
(65.5 x 86 cm). Staatliche Museum
zu Preussicher Kulturbesitz, Berlin.*
Dalí's visual, easily accessible art
appealed to his wealthy American
patrons, whose commissions for him
to paint their portraits provided him
with a good income during his stay
in the United States. The realistic
and detailed style which Dalí used
in his portraits was described by him
as his hand-painted photographs.

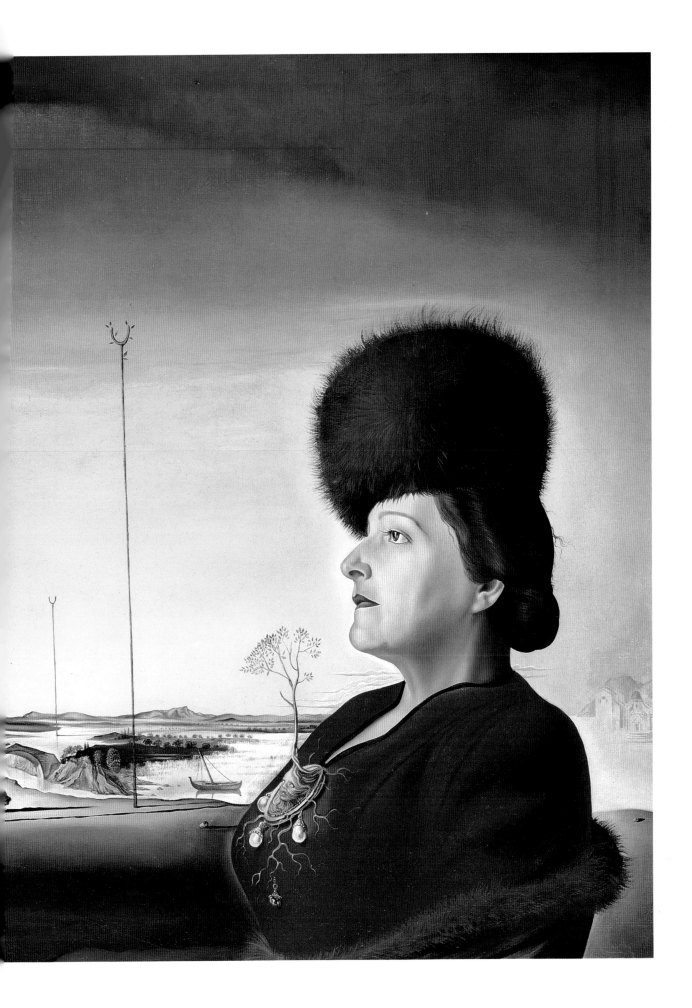

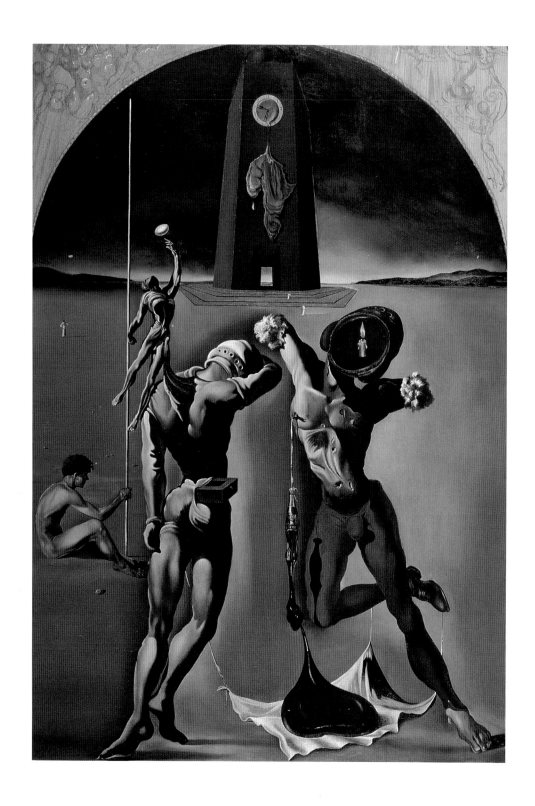

"The Poetry of America" or "The Cosmic Athletes"

c. 1977, oil on canvas; 45½ x 30 ⅔ in. (116.8 x 78.7 cm). Fundacion Gala-Salvador Dalí, Figueras.
In Dalí's work there is sometimes an ironic or sardonic comment,
as in this reference to life in the United States. In this second
version of a painting first done in 1943, Dalí has replaced the
American soft drink with a bottle of French wine.

Nature Morte Vivante (Still Life—Fast Moving)

1956, oil on canvas; 49 x 62½ in. (125.7 x 160 cm). Salvador Dalí Museum, St. Petersburg, Florida.
The fast-moving still life is from the realm of Dalí's scientific view
of life through physics. The carefully painted objects fly about in
space like atomic particles and Dalí's hand with a rhinoceros horn
suggests the role of sex, even in a scientific concept of the universe.

Venus and Sailor

1925, oil on wood; 16⅞ x 12⅛ in. (42.8 x 31.4 cm). Ikeda Museum, Shizuoka, Japan.
Among the works shown at Dalí's first exhibition at the Delmau Gallery in
Barcelona in November of 1925 were *Venus and Sailor*, Cubist paintings of
1924, *Portrait of My Father* (1925), and *Girl Seated, Seen from the Rear* (1926).

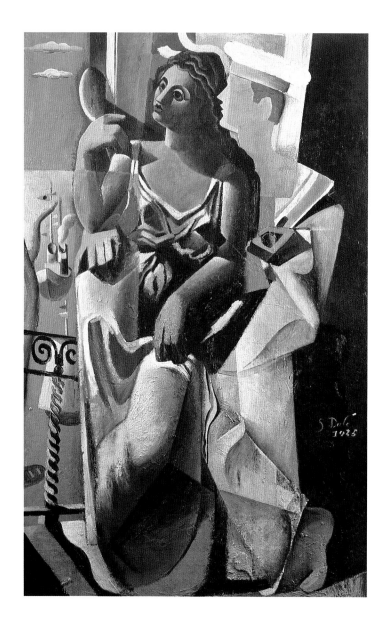

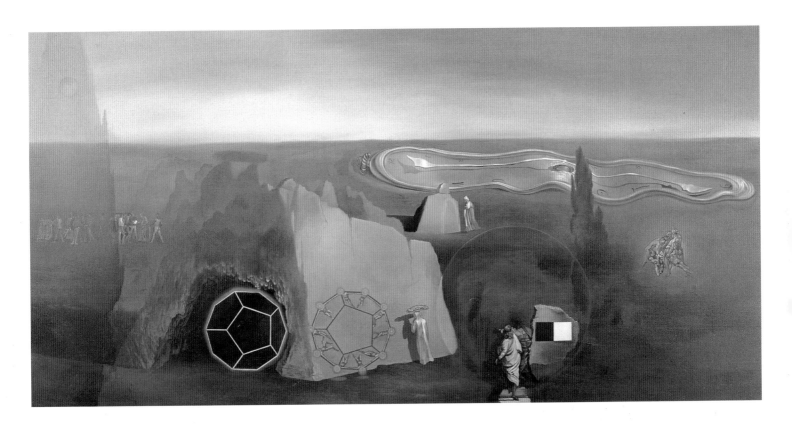

Searching for the 4th Dimension

1979, oil on canvas; 47¾ x 96 in. (122.5 x 246 cm).

Fundacion Gala-Salvador Dalí, Figueras.

Dalí's constant search for images outside the conventional
world drove him into explorations of time and space in which
nothing was what it seemed. Here, many of the images are
those which had long been part of his creative world—the
melting and the loaf of bread on the woman's head.

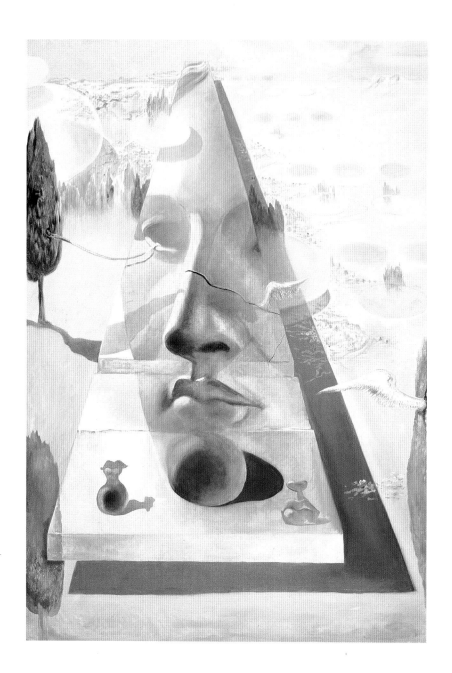

Apparition of the Visage of Aphrodite of Cnidos in a Landscape

1981, oil on canvas; 54½ x 37½ in. (140 x 96 cm). Fundacion Gala-Salvador Dalí, Figueras.
When he was not plunging into the subconscious or into the mysteries
of modern physics, Dalí traveled happily in the world of the classical
Mediterranean. This derived from his childhood near Cadaqués, where
ancient remains included the ruins of the port of Ampurias, where Greeks
and Romans traded goods, bringing their culture to Spain in the process.

The Path of Enigmas

1981, oil on canvas; 54¹/₂ x 36 ²/₃ in. (139 x 94 cm). Fundacion Gala-Salvador Dalí, Figueras.
The flying moneybags in this paintings are in the Dalí nuclear
physics mode, though they also echo a much earlier painting, *Inaugural
Gooseflesh* (1928), which showed amorphous drops of white matter
flying through space. The moneybags here perhaps refer to Dalí's time
in the United States, when Breton had nicknamed him "Avida Dollars."